Starlet | FIRST STAGE AT THE HOLLYWOOD DREAM FACTORY

UNIVERSE PUBLISHING

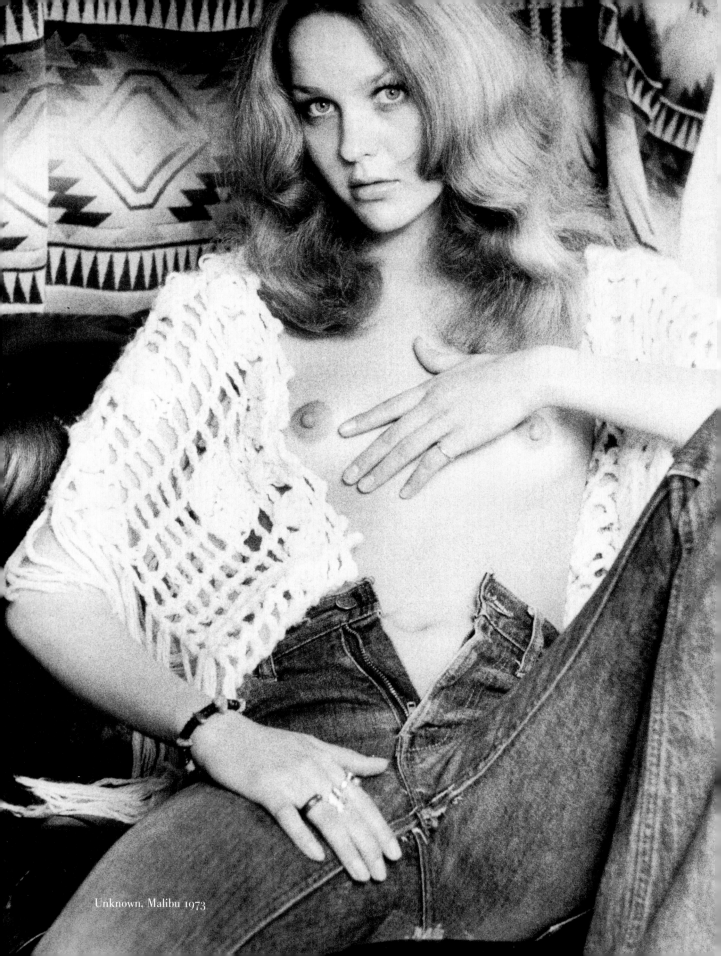

Unknown, Malibu 1973

UNIVERSE PUBLISHING

Photographs by

NANCY ELLISON

INTRODUCTION BY PAUL THEROUX

Starlet

FIRST STAGE AT THE HOLLYWOOD DREAM FACTORY

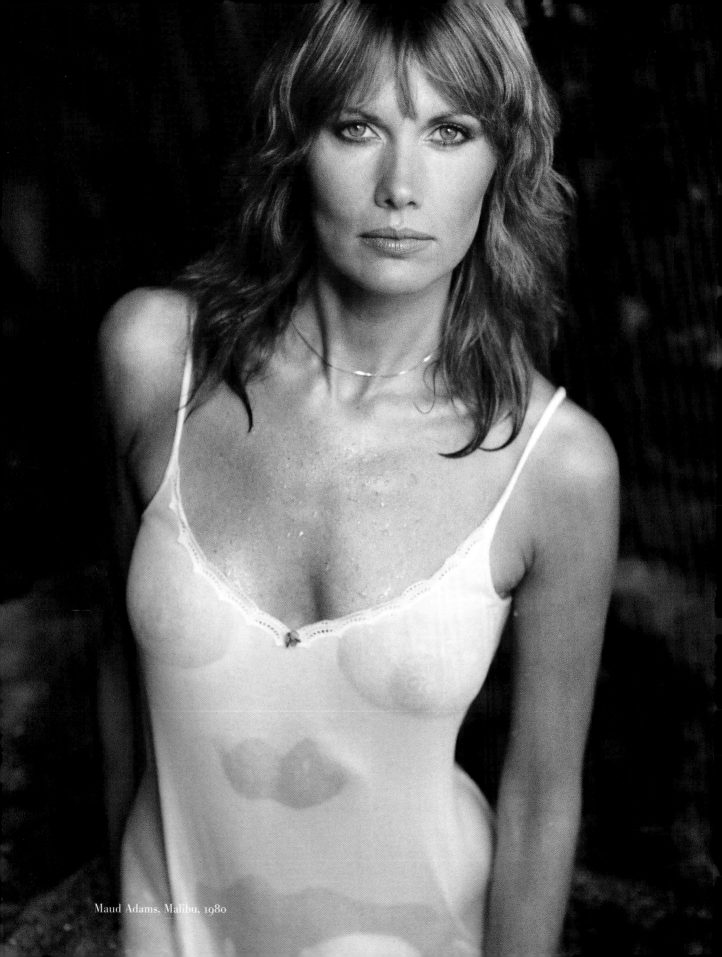

Maud Adams. Malibu, 1980

for Bill | MY DREAM KEEPER

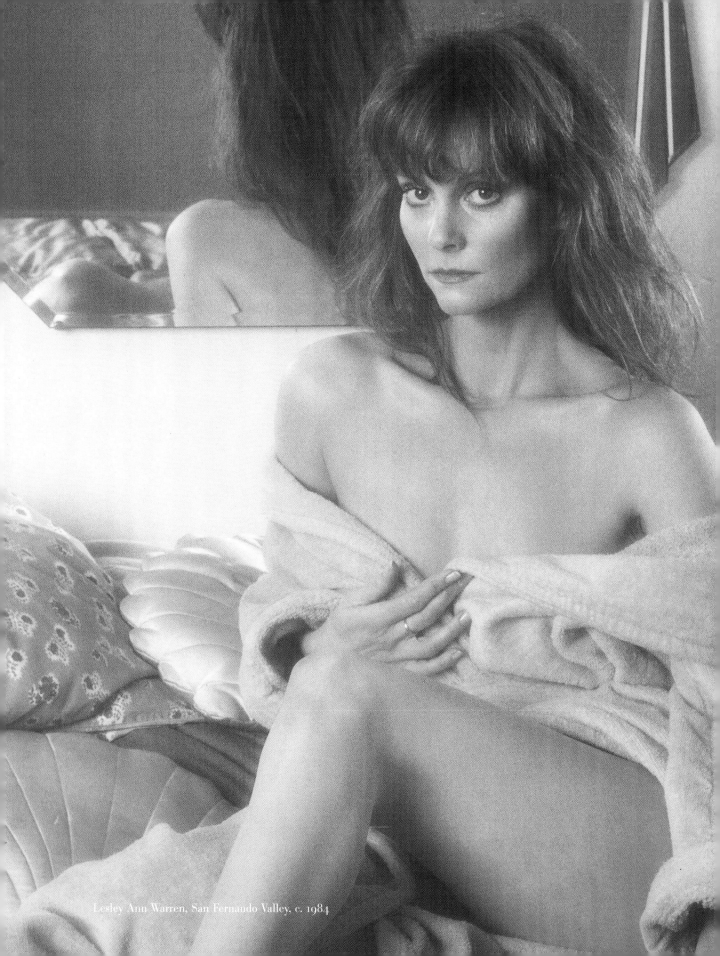

Lesley Ann Warren, San Fernando Valley, c. 1984

Roster

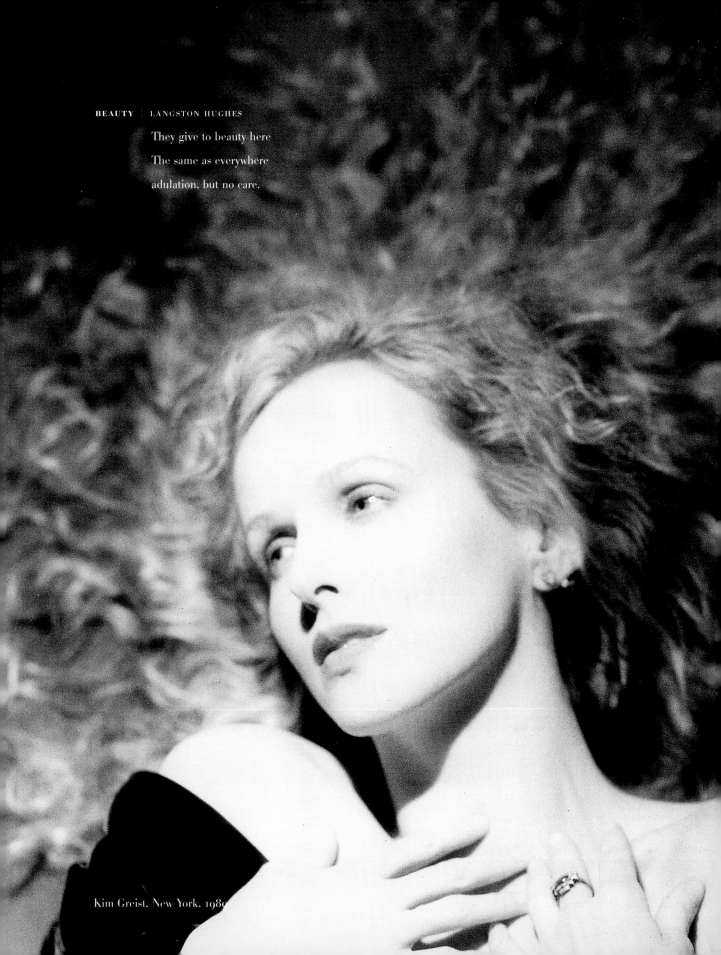

BEAUTY | LANGSTON HUGHES

They give to beauty here
The same as everywhere
adulation, but no care.

Kim Greist, New York, 1989.

Beautiful Dreamers | NANCY ELLISON

BEAUTIFUL DREAMERS, YOUNG, UNKNOWN, yet so eager, so hopeful, climb onto the Hollywood carousel to capture its golden ring: STARDOM—and all the fame, recognition, limos, wealth, Oscars, and happiness it provides . . . or so they dream.

And then they make the rounds . . . but, "Babe you're on your own!"

To paraphrase Margo Channing in *All About Eve*, "Fasten your seat belts and hang on! This rite of passage is going to be a bumpy ride. . . . "

During Bette Davis's heyday, the rounds would have taken them to the Studios. Hollywood hopefuls had the protection of the all-powerful Studio System where they were given the celebrity-to-be finishing school treatment. It was the Studio that decided the imagery and style of a newcomer, and their photographers would work in tandem with the Studio to create the star out of the starlet. Since the break up of the studio system, young would-be starlets find themselves really on their own—with a lot of people around them quite willing to take, but a little less willing to protect and nurture. Photographing starlets in Hollywood is still about as everyday as having breakfast. Show business, with its insatiable psychic eating disorder, eternally and voraciously feeds on its youth.

When I was young there were two great fantasy objects among the boys I knew: the nymphomaniac whose father owned a liquor store, and the blonde in a fuzzy pink angora sweater that delicately covered her pointy bra. I never knew a bonafide nympho, but in Southern California where I grew up there was a plethora of those luscious tantalizing blondes with all that fuzzy pink innocence covering twin towers of pointy deceit. Angel-whore! The power of available innocence, the hint of naughtiness, the common man's debutante bowing in a peasant blouse at his feet. . . . To the viewer, the starlet holds this promise, availability, surrender, and finally, possession.

Since *Blow-Up*, the image of the hip photographer has been the prototypical David Hemmings astride a luscious, writhing model: all powerful and vibrating, flash and sparks.

Since I am female, I bring a different dynamic to the process. With another woman, I choose to be in collusion with her—to seduce the world with her beauty. I go to the obvious: What has she got that no one else has? When I find that in a subject, she will burn with an afterglow—no matter what age. Undoubtedly I am projecting, sublimating, living vicariously . . . whatever. That's the whole point.

Men as starlets—sounds odd—but the truth is, young men find themselves facing a similar rite of passage. (They may even find themselves facing similar lions and tigers and bears, oh my!) When photographing them, other dynamics emerge. Some try to seduce my

lens (please note "lens") others, amazingly, are shyly awkward and need coaxing, and sometimes I'll make my camera the Alpha Dog rendering hunks of the day "vulnerable." The goal whether shooting men or women is to produce the desirable sexual object.

Probably the way an actor files memories during a performance, I have my own file: the first time a boy asked for a lipstick imprint of my mouth; the first time someone kissed me and I knew others were watching; or the first time I tried walking like Marilyn Monroe on the street and getting wolf whistles. (Please don't tell me you're too much of a feminist to have tried it!) Other issues of titillation: a cheerleader showing her white panties as she jumps; the form of nipples under a sweater; the way hair falls covering a young girl's face; the virgin dreamer, the Loralie Eve, the bored sex object; the girl next door who might let you touch; the sun goddess, the bimbo, the harem siren, the mistress, the hippie, free lover, the brassy secretary. . . . The references are both familiar and infinite.

However, these are concepts, and I am essentially an imagist. It is the imagery that creates the desirability of the subject. As I mentioned, in the old days the studio decided the "look" that surrounded a starlet. Pigeon holes awaited the arrival of each young girl: Debbie Reynolds—perky, virginal girl next door; Ava Gardner—the barefoot sex goddess (probably every boy's vote for that nymphomaniac whose father owned the liquor store); Marilyn Monroe—the ultimate non-threatening-eager-to-please-dumb blonde (and by God they bloody well better stay that way). Now when star-

lets make the rounds of photographers, each photographer may have a different take on the girl they see. Unless the actress herself is either manufacturing her own image or her essence is so obvious, the public will never have a clear projection of her.

When I work, I try to create a space, a vacuum, in order to find the life blood of the person I'm shooting. In the beginning of a session, my relative silence forces my subjects to give me their look. Often with young girls, these first poses are programmatic echoes of images they have seen of other starlets. They think they have given me what I want and in some cases they are right. Sometimes, the very predictability of the pose is interesting to me. As if we are speaking in shorthand ("I'm young. I'm available. I'll touch my breast lightly—you'll understand"). Signals, code references, and posturing are all part of this stage in actors' careers. To those who want to attract their audiences simply, I comply.

For others who are themselves searching and who are looking to the photographer for guidance, or for those who are uncomfortable with the whole "starlet" thing, the session takes on the quality of discovery. If someone is shy, I photograph their shyness. It becomes their loveliest trait. If someone is smart or dreamy, I shoot that. The imagery reveals itself. To that end I keep the logistical elements of the session as loose as possible: indoors or outdoors, natural or artificial lighting, seamless or natural environment, make-up heavier or lighter. To that extent, I have learned to "spin on a dime;" to stop a set-up if it doesn't feel right, to shift focus, to reverse the imagery altogether. While it may

appear to some (mostly my assistants who want all the shots and requirements lined up in advance) that I don't know what I want. I know exactly what I want. I want what I don't know!

There was a young blonde (what else?) brought to the Cannes Film Festival who made the rounds of parties and events with a series of "producers." With each event she became more Monroe—even adopting (along the way) the whisper voice. She began to sadden me and to haunt my thoughts. What would become of her? Would I ever see her in a film? I never saw her in a film, but I did find out what happened to her: she became a shopgirl.

For most people she is the quintessential image of the starlet: used, abused, and discarded—but it is not always such. Young people left to fend for themselves find a way to succeed or drop out on their own terms. Perhaps part of their choice is based on Hunger (to feed on or to be the feed of stardom?), or perhaps it has to do with the Game. Can you beat the odds—beat the system? Some of my "starlets" have been working their asses off (no pun intended) for ten or fifteen years before they get recognized. (Can any of us hang tough that long?) Some may take a good long look at Hollywood and decide "this isn't for me," while there will always be those reckless free spirits who in the rapture of their salad days come to play in and with Hollywood—like some extended spring break—before they decide to grow up. You'll find them all in the following pages.

Starlet is an homage to all of those beautiful creatures who posed for my camera hoping for stardom, and to their youthful dreams. As you will see, many actually became superstars. Some will be recognized as solid hardworking actors, while others existed so ephemerally only their beautiful images and the dreams they represent remain. But, they all DARED; they risked everything; and their beauty will always remain as they once dreamt it.

THE DREAM KEEPER LANGSTON HUGHES

Bring me all of your dreams.
You dreamers.
Bring me all of your
Heart melodies
That I may wrap them
In a blue cloud-cloth
Away from the too-rough fingers
Of the world.

FOLLOWING PAGES: Sharon Stone, Mexico City, 1989

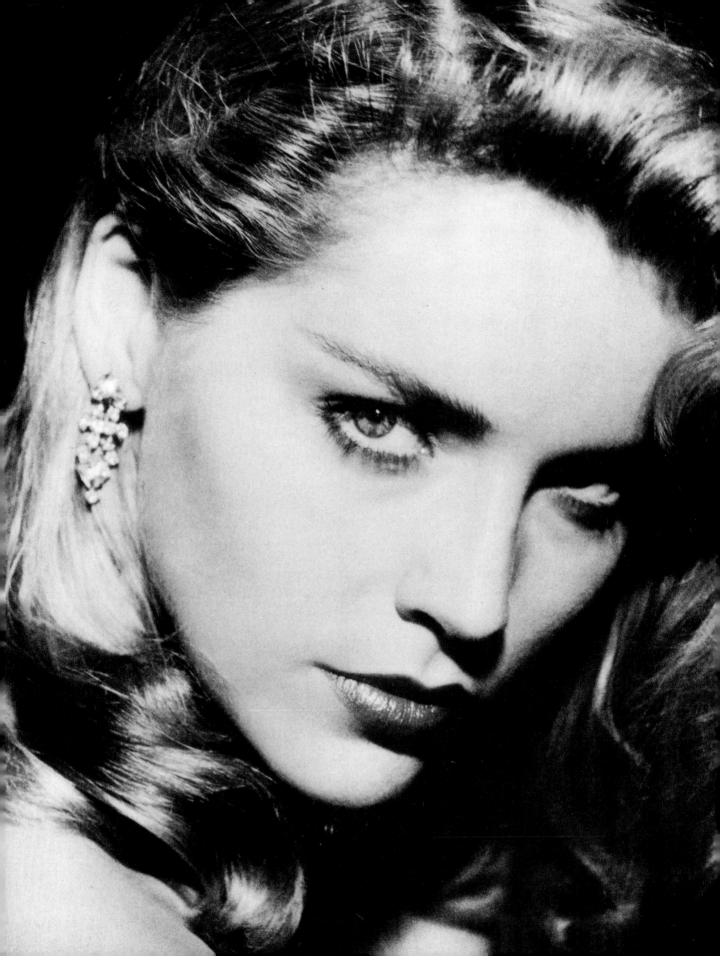

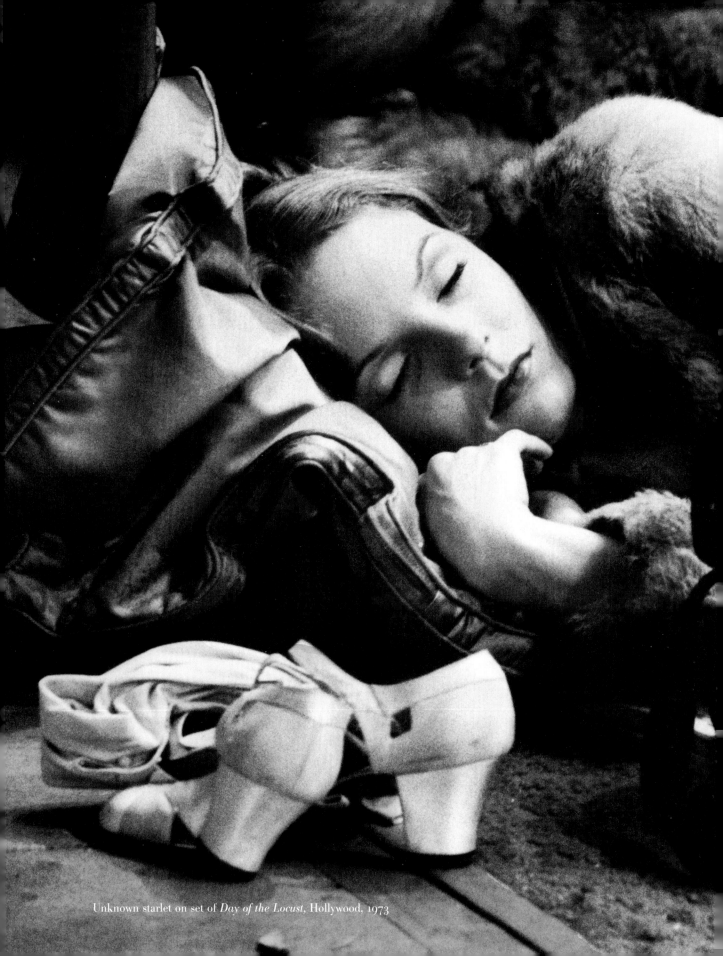

Unknown starlet on set of *Day of the Locust*, Hollywood, 1973

Starlet | PAUL THEROUX

The starlet first twinkles on a movie screen, in an uncredited role listed on the last crawling titles as, for example, "Girl in Rowboat," yawning and stretching and rising to leave the theater: You think *Which girl? Which rowboat?* Only much later in retrospect are you able to match the mature box office sensation with the simpering young thing fuddling about with a paddle—for it was a paddle not an oar, and a canoe not a rowboat, and the girl a teenage unknown named Marilyn Monroe.

This particular movie (described as forgettable yet I have not forgotten it) was *Scudda-Hoo! Scudda-Hay!* (1948), a starlet vehicle (Natalie Wood and June Haver also appeared), in which Marilyn made her first brief appearance as "Girl in Rowboat." I first saw it one summer in the early 1950s in, of all places, St. Francis of Assisi Church Hall in Medford, Massachusetts, with hundreds of sweaty preteens attending summer school. God knows who chose it for us. It was about mules

(the title is derived from the sort of holler a mule team needs as encouragement) – and was also about hayseeds and hicks and farmers' daughters. Perfect viewing for a priapic adolescent on a hot afternoon. Marilyn appeared briefly—mere seconds, giggling bare shouldered in a summer dress in her bobbing boat. It goes without saying that she went on to bigger things but it is significant that while she was a starlet in this movie she was also posing for nude calendar shots and was already for many men, inside and outside the movie industry, an object of desire—gifted with sexual, rather than acting, talent.

That Marilyn cameo in the mule-team movie seems to me the classic starlet sighting. There are not many starlets in fiction, but their scarcity is compensated for by their vividness. Faye Greener in Nathanael West's Hollywood novel *The Day of the Locust* comes immediately to mind. But the fullest fictional history is that of Margot Peters, the young woman who seduces and, ultimately destroys Albinus, the

main character in Vladimir Nabokov's black comedy *Laughter in the Dark*. Set in 1920s Berlin, this novel seems to me one of the greatest portraits of a starlet in all literature—greediest, most manipulative, prettiest face, deepest cleavage.

I n the opening pages of the novel, in which she works as an usher in a Berlin movie house, "Margot dreamed of becoming a model, and then a film star. This transition seemed to her quite a simple matter: the sky was there, ready for her star."

Margot reads biographies of film stars (notably, Greta Garbo's) and is constantly talking about her cinematic ambitions. The novel can be dated by a mocking observation Albinus makes about "the comparative merits of the silent film and the talkie." "Sound," Albinus says, "will kill the cinema straightaway."

*M*argot's dream is the archetypal vision of "the diamond bright world" of all starlets: "Margot had only a very vague idea of what she was really aiming at, though there was always that vision of herself as a screen beauty in gorgeous furs being helped out of a gorgeous car by a gorgeous hotel porter under a giant umbrella." Ultimately she sees herself on screen and is horribly disappointed—appalled by her brief, clumsy appearance:

> "Awkward and ugly, with a swollen, leech-black mouth,
>
> misplaced brows and unexpected creases in her dress,
>
> the girl in the screen stared wildly in front of her...."

The novel, a love story that is a rehearsal for and a precursor to *Lolita* (old smitten man, childish willful lover) also describes betrayal, cruelty, seduction, disillusionment and murder. These horrors are not entirely absent from the classical definition of starletdom, for in any full-colored description of the starlet she is depicted as a waif, a schemer,

a sulky child, a seductress; she is young, she is reckless. She often appears in movies with titles like "The Young and the Reckless." She is also, so to speak, at risk. The dismembered torso or violated woman in the Hollywood violent crime story is invariably described in the caption as a starlet.

The starlet's *Look-at-me!* expression gives her the face of a victim, a look of both willingness and innocence. *I'm yours*, the face seems to say, conveying loveliness and availability, and implying whole world of carnality. The man of the world smiles inwardly in the knowledge that such a person has got to be a little disturbed, somewhat difficult, vaguely dysfunctional, possessed with the sort of ambition that easily becomes colorful megalomania ("gorgeous furs … gorgeous car … giant umbrella").

Often, the starlet is the sort of star-struck applicant whose waywardness is explained not by men but by other woman who say, "She's sad, plus she's got real low self-esteem and comes from a real dysfunctional family. I mean, like she was abused by her step-father." A director observing such a distracted, needy and manipulative woman is not pitying but hopeful and thinks: Putty in my hands! There is a suggestion of salaciousness in the definition and the very word starlet even sounds (perhaps unfairly) like slut.

But these are aspects of a definition informed by stereotype, bias, hearsay, and the oral tradition, and faulty for that reason. The true definition of a starlet seems impossible to achieve. I consulted eight authoritative—or at least well-known—dictionaries and got almost nowhere. The definitions were vague and sometimes contradictory.

"A promising young performer, esp. a woman"

—OXFORD AMERICAN DICTIONARY

"A young film actress publicized as a future star"

—AMERICAN HERITAGE DICTIONARY OF THE ENGLISH LANGUAGE

Same wording but "represented as a future star"

—FUNK AND WAGNALL'S

"A young actress who plays small parts in movies and is
hoping to become famous"

—LONGMANS DICTIONARY OF THE ENGLISH LANGUAGE

"*Often disapprovingly.* A starlet is a young actress who hopes to be
or is thought to likely to be famous in the future"

—CAMBRIDGE INTERNATIONAL DICTIONARY OF ENGLISH

"A young actress—esp. in motion pictures"

—RANDOM HOUSE DESK DICTIONARY

"A young movie actress being coached and publicized for starring roles" —LANGENSCHEIDT NEW COLLEGE MERRIAM WEBSTER

"A young woman actor billed as a major movie star of the future" —ENCARTA WORLD ENGLISH DICTIONARY

All these definitions contain a grain of truth. "Often disapprovingly" is the canniest suggestion of all. The word "star" in the sense of a luminous and celebrated performer, dates from the early nineteenth century. "Starlet"—which also means "small star" and is the name for the starfish *asterina*—dates from 1920, (according to *20th Century Words*, by John Ayto) where it first appeared in print in a ditty by one J. Ferguson:

"Some 'starlet' sings
Into the footlights glare"

Starlets were numerous in the early years of Hollywood. The film historian Ephraim Katz wrote, "Pretty girls by the hundreds signed on low-paying long-term contracts and were given training, publicity and minor roles in major films, in the hope they would develop into bona fide stars." And as a sort of epitaph for starlets he concluded, "Only a few ever made it."

Verbal descriptions and dictionary definitions are not much use where starlets are concerned. Language fails to do justice to the prettiest face. This has a certain poetic truth since the received wisdom is that starlets are the least bookish of people, not to say illiterate. This cannot possibly be true, but such a view adds to the appeal, for in the mind of the simple-minded and predatory male a woman's low IQ is part of her beauty. But because a dictionary is little help in, let's say, adumbrating the nuances of the starlet, photographs, and especially Nancy Ellison's photographs are a necessity. The starlet is a work in

progress, not yet an icon, and great pictures provide all the complex suggestions and associations that are lacking in dictionaries.

The portraits in this book encapsulate all the possible meanings—the siren, the waif, the girl with screen potential, the babe, the expressive face, the eloquent buttocks. The starlet is depicted with the greatest subtlety in a photographic portrait—not in a walk-on or a cameo in a movie. Many of Nancy Ellison's photographs show aspiring actresses who went nowhere. Some are names in the *Where are they now?* file. One of the strange conjuring tricks of show business is the transformation that promotes some actresses to glory, and makes others vanish without a trace. It is not impossible that some of the women in these photographs are at this moment signing up for dieting classes, or 12-step programs; or running for public office, or driving their kids in the minivan to soccer practice.

But this book, which is an album of an industry, is also a

valuable historical document for some of these novices were actresses who emerged from the postures of weakness and vulnerability into professionals of real accomplishment, stars with great strength and considerable character, and a wide range of ability. Sharon Stone, Rosanna Arquette, Anne Archer, and Kim Basinger are some in whom it is possible to see the powerful promise in the early portrait.

One is reminded that the starlet, typically, is a very young, very pretty, seemingly unaffected and simple dollface, until you take a second look and see more complex nuances, some of them worrying, others laudatory. The very pose and facial expressions suggest talent, or its lack. In each face there is hope. In some this hope is conveyed in a sort of job applicant's eagerness to find employment, but in most it is not a simple wish at all but a longing for a career, for a partner, for a life.

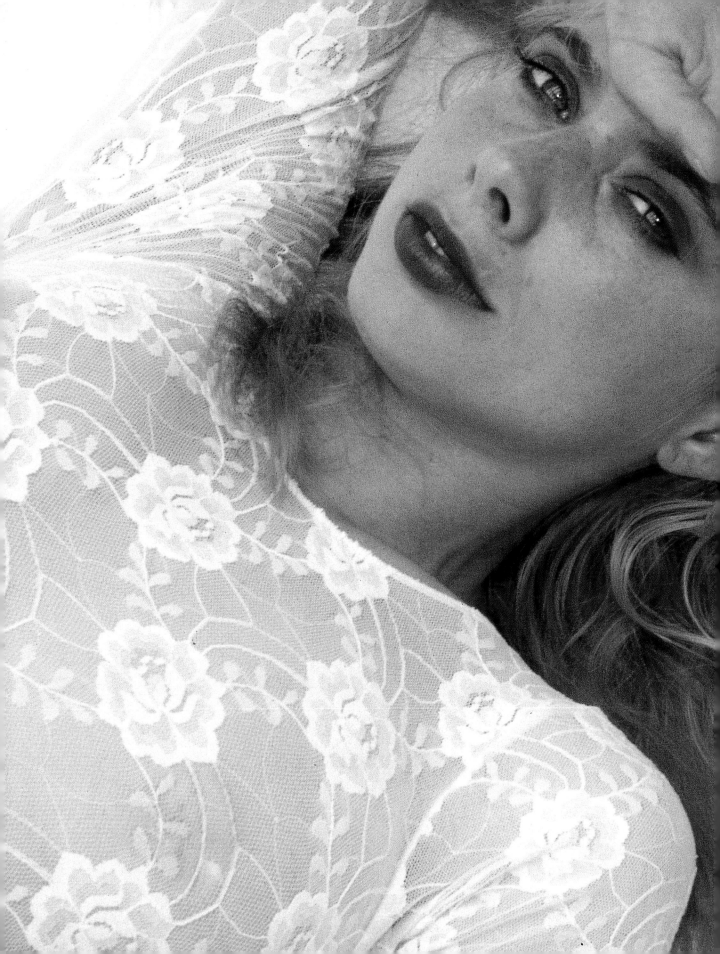

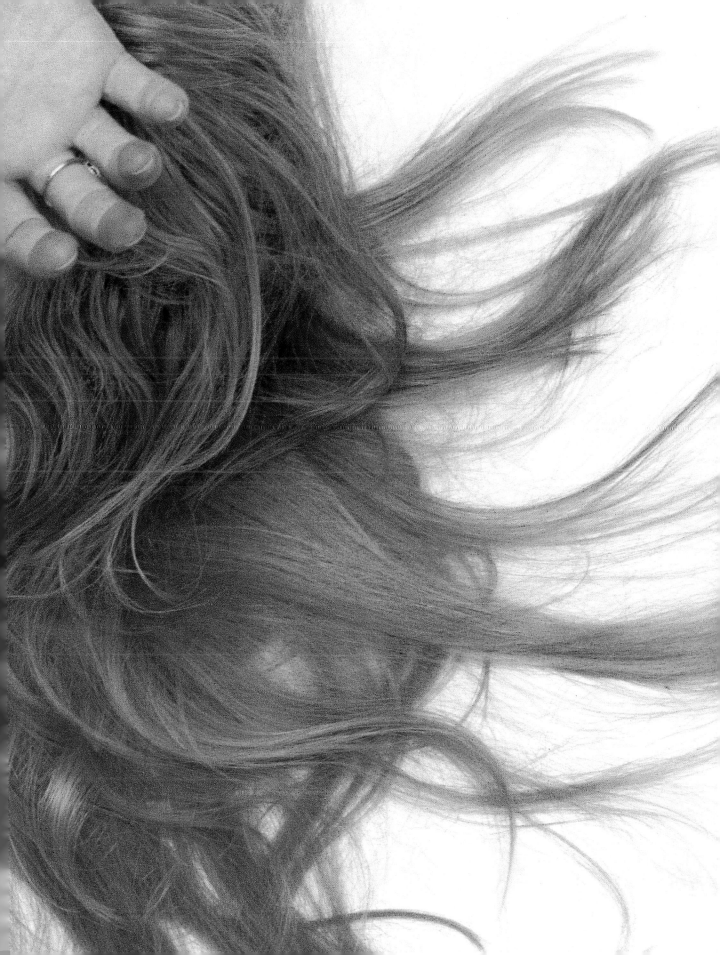

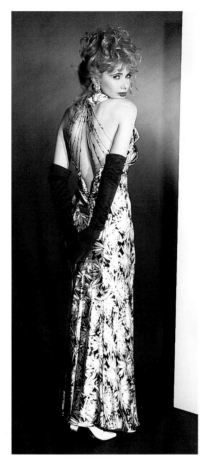
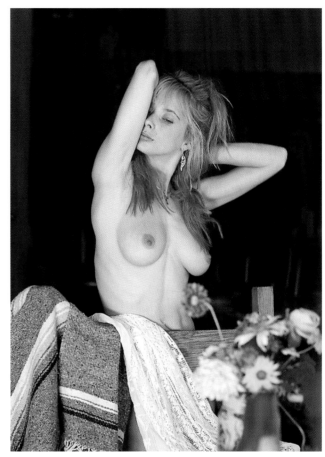

Rosanna Arquette | VENICE, C. 1987 (top left); BIG SUR, 1988 (top right and opposite)

How can anyone be so easy and so intense at the same time? Ro has always been incapable of doing *anything* halfway—as an actress or as a friend. All that talent, vulnerability, sexuality, heart, and emotional energy rests on a razor's edge, which makes photographing her an adventure in trust—without a script. Sympathetic to underdogs, Rosanna has been known to reject commercial films for quirky, independent projects.

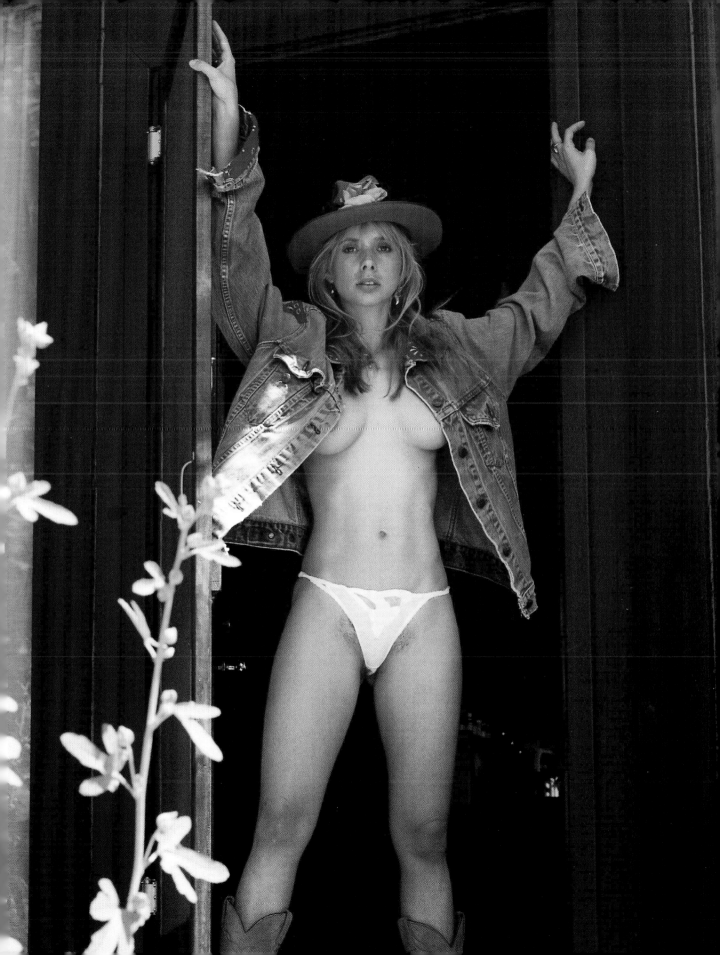

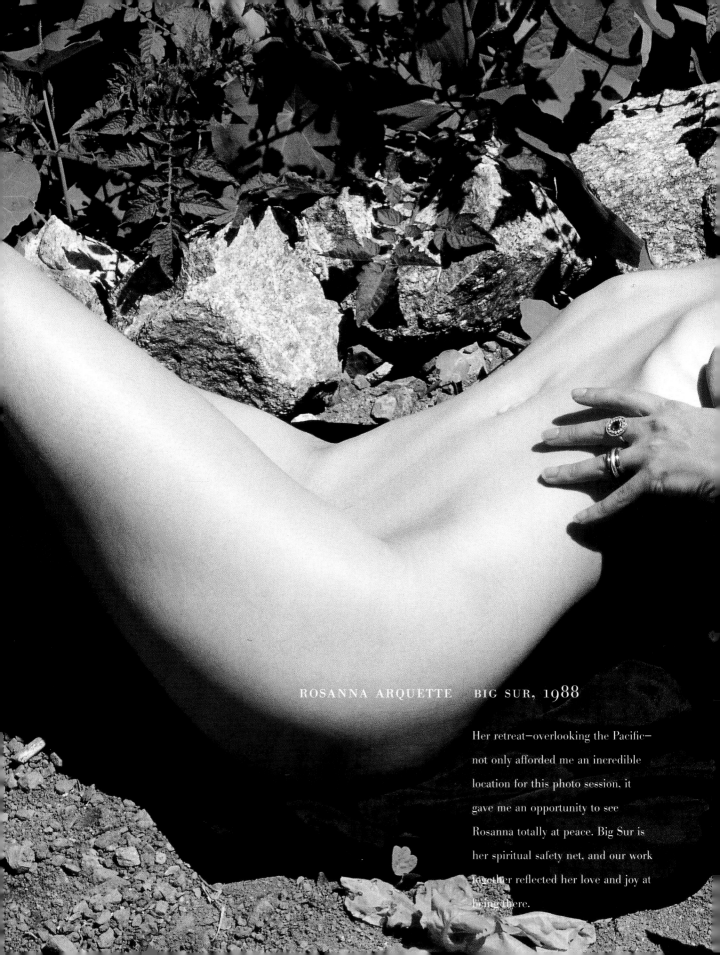

ROSANNA ARQUETTE BIG SUR, 1988

Her retreat—overlooking the Pacific—
not only afforded me an incredible
location for this photo session, it
gave me an opportunity to see
Rosanna totally at peace. Big Sur is
her spiritual safety net, and our work
together reflected her love and joy at
being there.

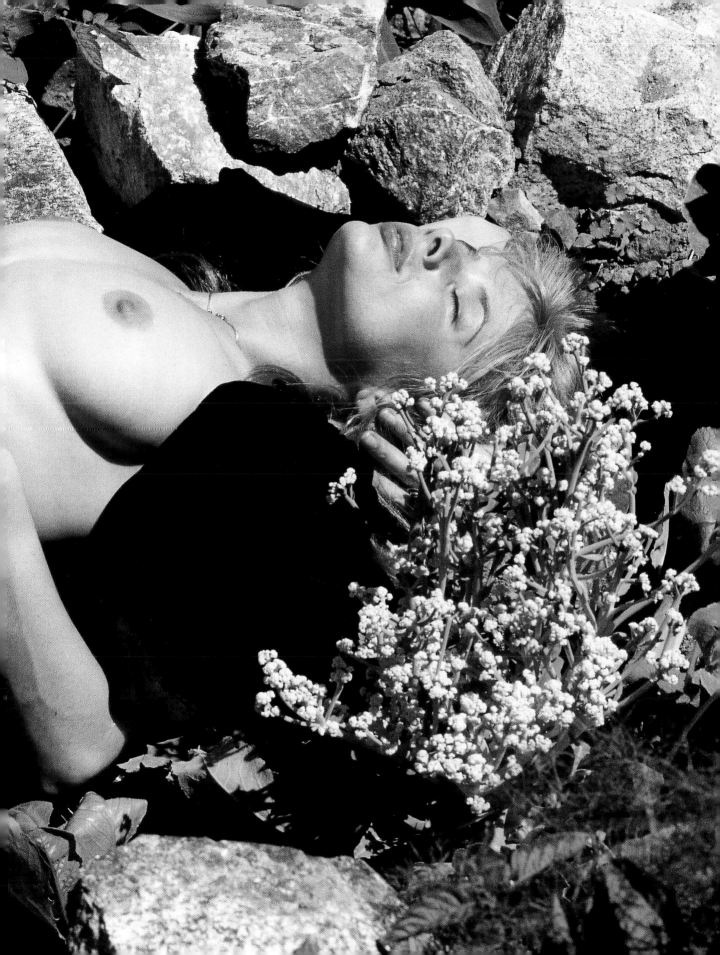

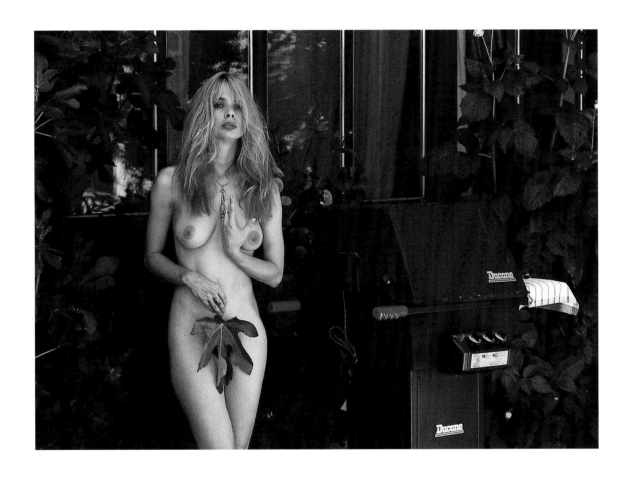

ROSANNA ARQUETTE | BIG SUR (above), 1988; MALIBU (right), 1988

Le Grand Bleu made Rosanna a
sensation in Europe and the media
was desperately seeking photographs
of her. *Max* got mine.

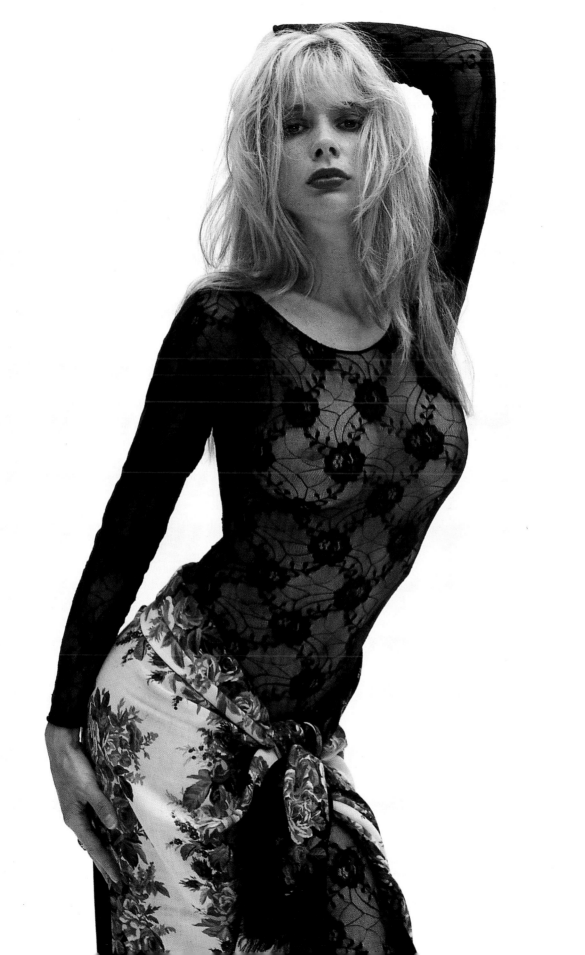

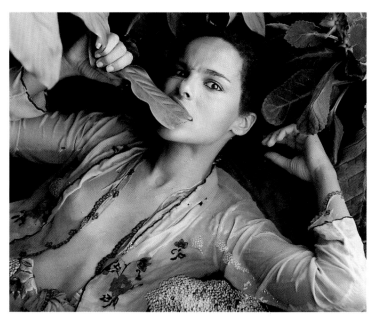
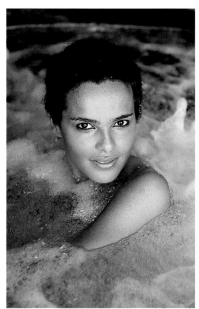

Shari Belafonte | MALIBU, 1981

Shari Belafonte, with her flawless, luminous skin and brilliant smile, was unbelievably photogenic, and she was startling—not just for her undeniable beauty—but for the astonishing similarity to her father, Harry. I was getting a twofer.

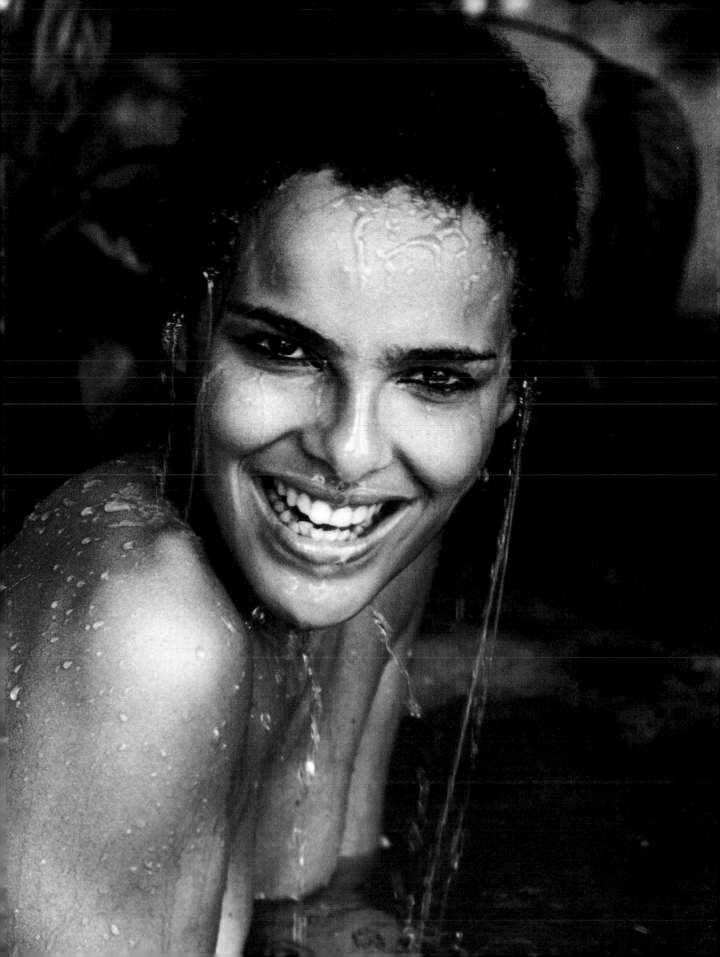

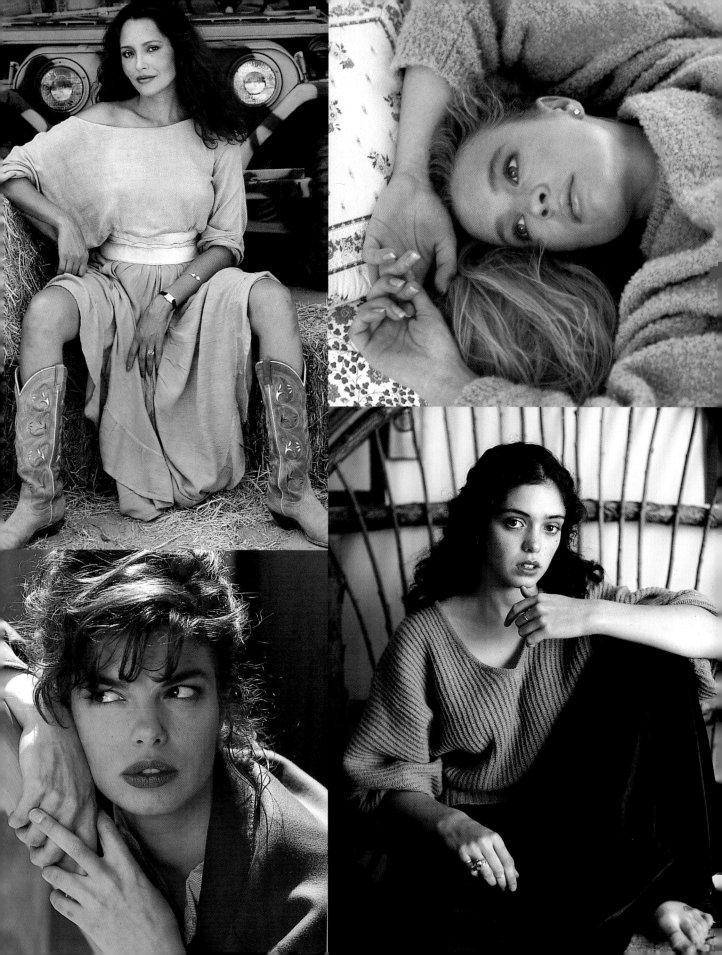

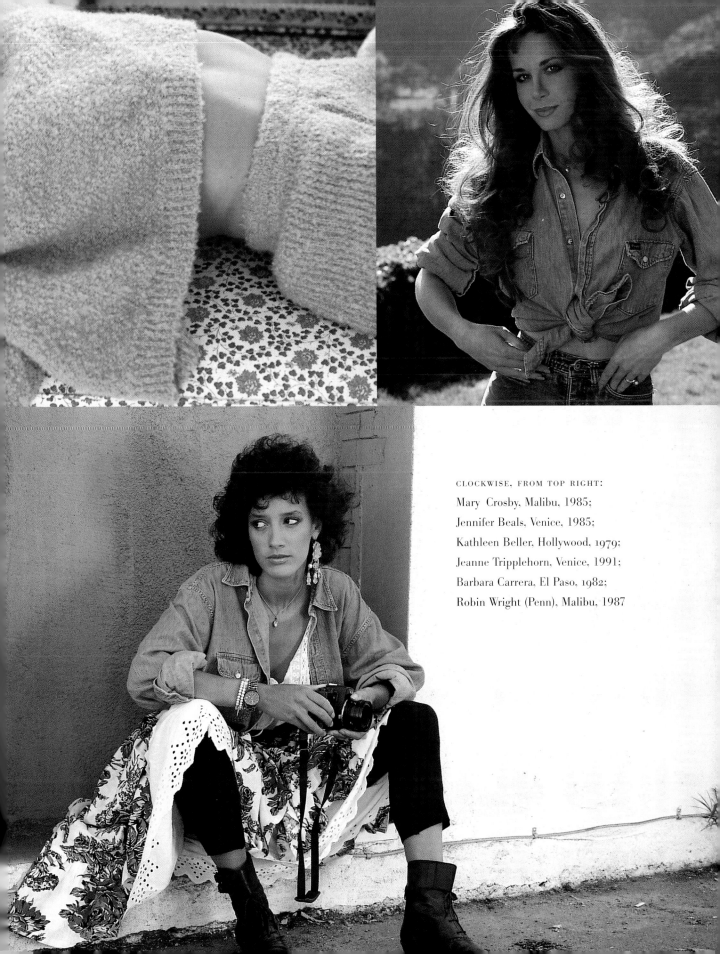

CLOCKWISE, FROM TOP RIGHT:

Mary Crosby, Malibu, 1985;

Jennifer Beals, Venice, 1985;

Kathleen Beller, Hollywood, 1979;

Jeanne Tripplehorn, Venice, 1991;

Barbara Carrera, El Paso, 1982;

Robin Wright (Penn), Malibu, 1987

Jamie Lee Curtis | MALIBU, 1990

Jamie Lee Curtis—second
generation Hollywood and hip to
the scene—takes everything in
stride. Whether it's hanging out of a
helicopter or crouched in the closet
screaming in horror, she's always
kept her cool.

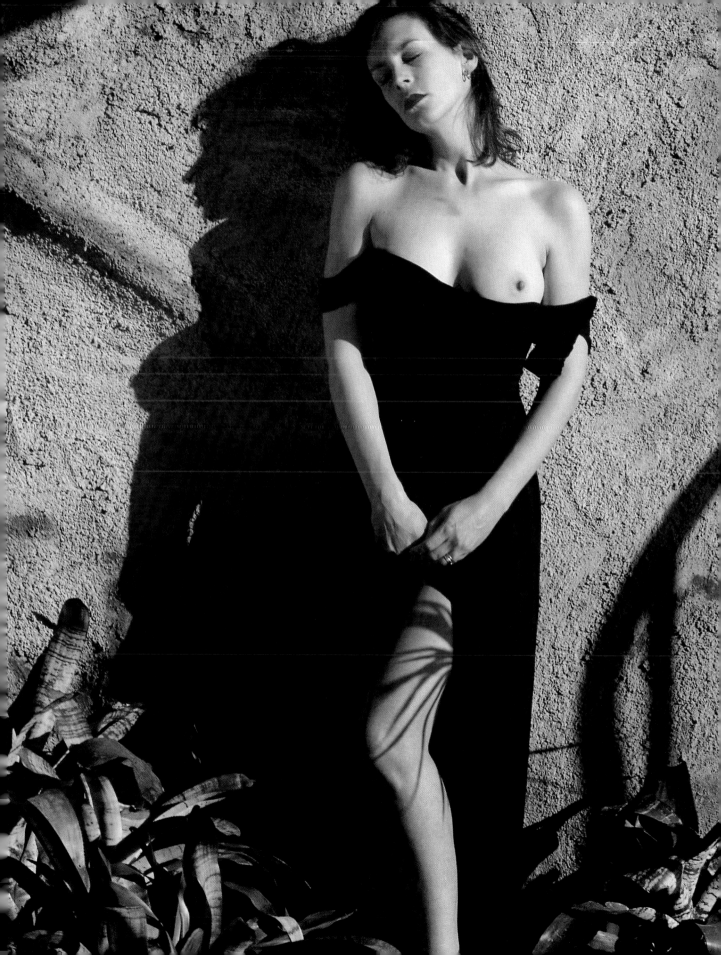

Geena Davis | VENICE, 1988

Beautiful and six feet tall, Geena
Davis exercised her options: Victoria's
Secret model or Academy Award–
winning movie star? Learn Swedish
or join the Olympic Archery Team?
She's tried them all.

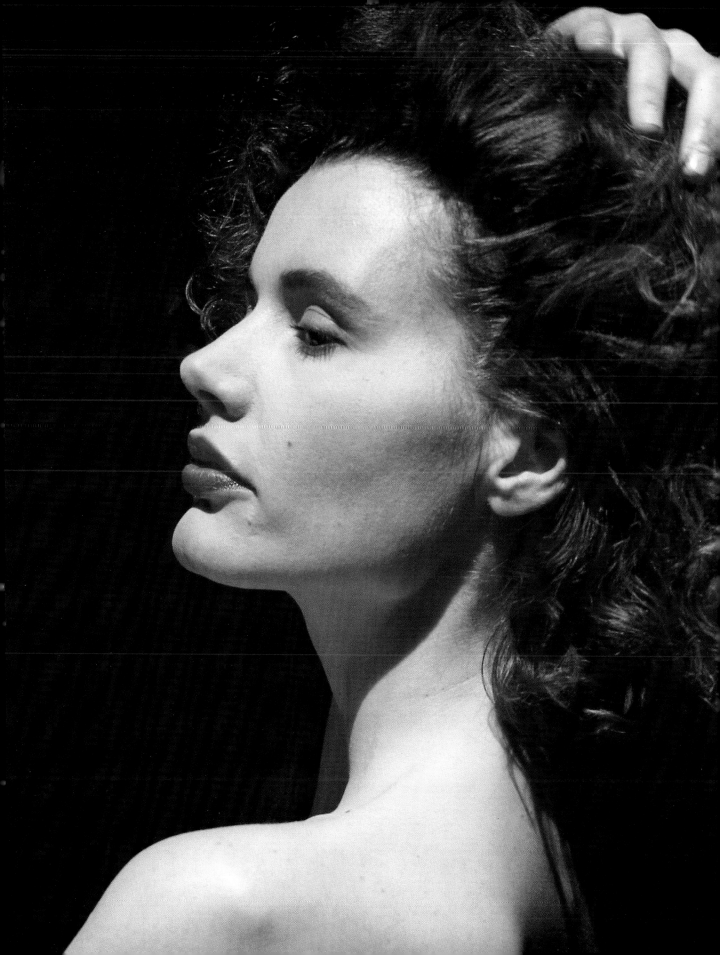

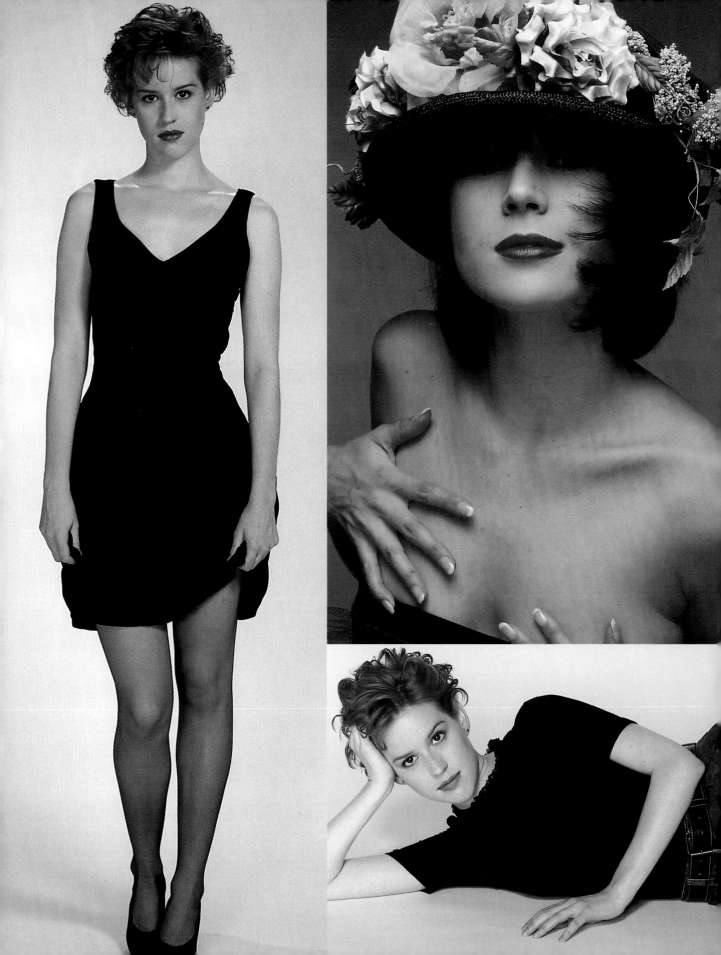

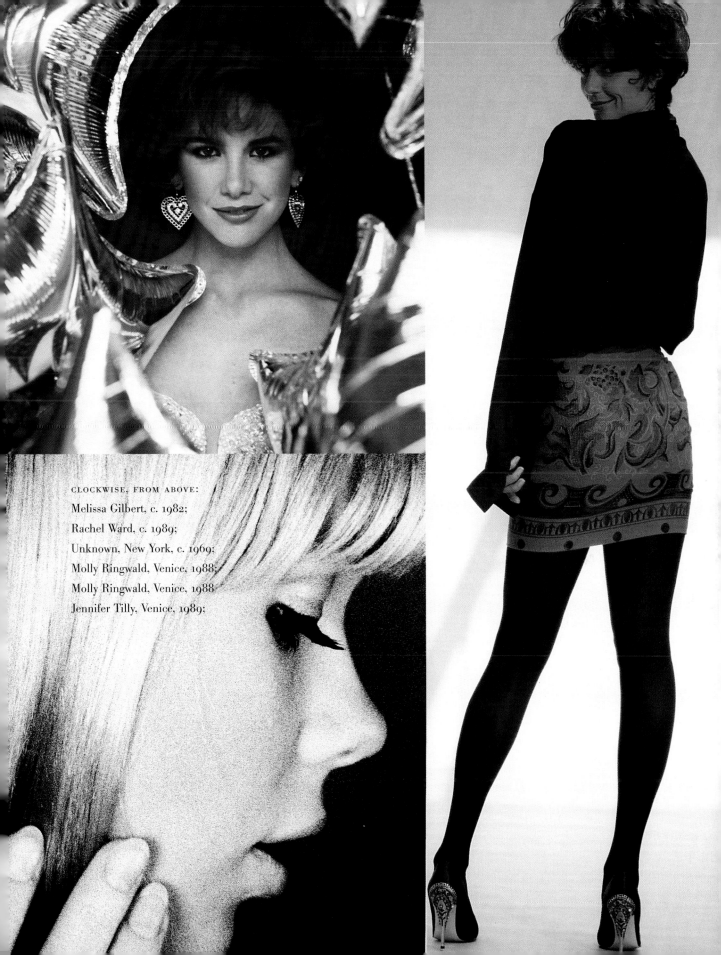

CLOCKWISE, FROM ABOVE:

Melissa Gilbert, c. 1982;

Rachel Ward, c. 1989;

Unknown, New York, c. 1969;

Molly Ringwald, Venice, 1988;

Molly Ringwald, Venice, 1988

Jennifer Tilly, Venice, 1989;

Grace Jones | MEXICO CITY, 1989

Usually, waiting for Grace Jones had more the feel of *Waiting for Godot*. Not just hours late—she could be days late. Actually, she could be weeks late!

Once she finally arrived, however, she would become devotedly all yours: focused, inventive, and full of good spirits. Wildly *Grace Jones!*

This time she surprised everyone by showing up uninvited and unexpected while I was shooting the stars of *Total Recall*. Grace, who cannot find her way from Hollywood to Venice in California, managed to get to Mars (via Mexico City) in full make-up, ready to take over!

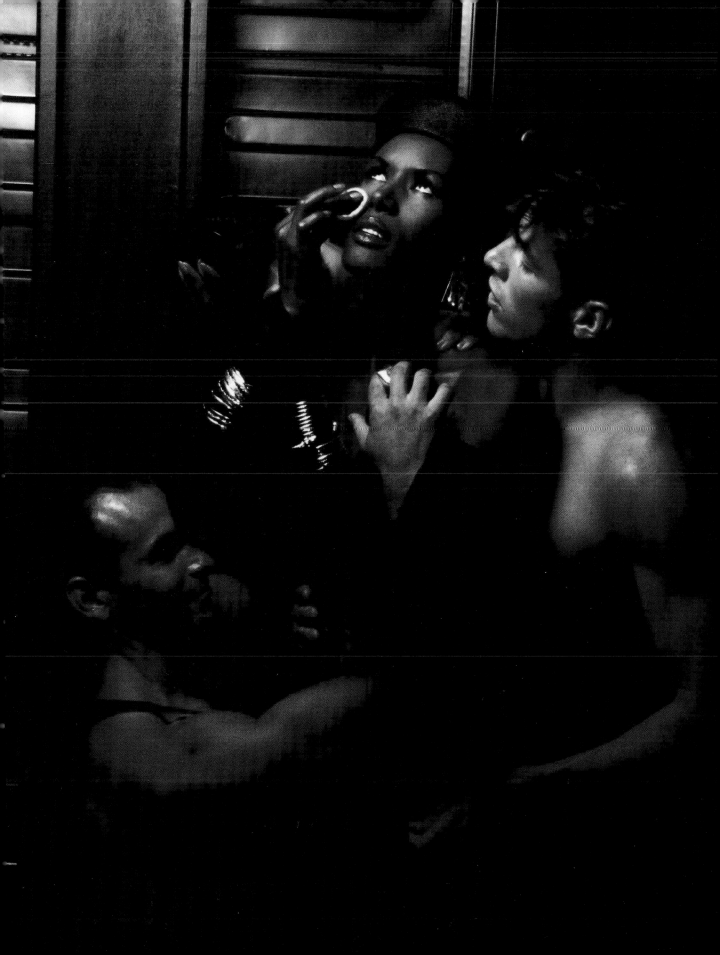

Unknown | PLAYBOY MANSION, C. 1980

Think of all those film images of waterfalls (usually in the middle of a jungle or volcanic island). Didn't they always have some secret, mysterious, and possibly dangerous passage behind them? During a *Vogue* shoot at the Mansion, I found myself *in* Hefner's grotto looking *out*. I was behind the waterfall at last! It seemed only fitting that I include, in silhouette, the ultimate fantasy—the starlet as mermaid bathing in utter innocence, unaware that she is being observed.

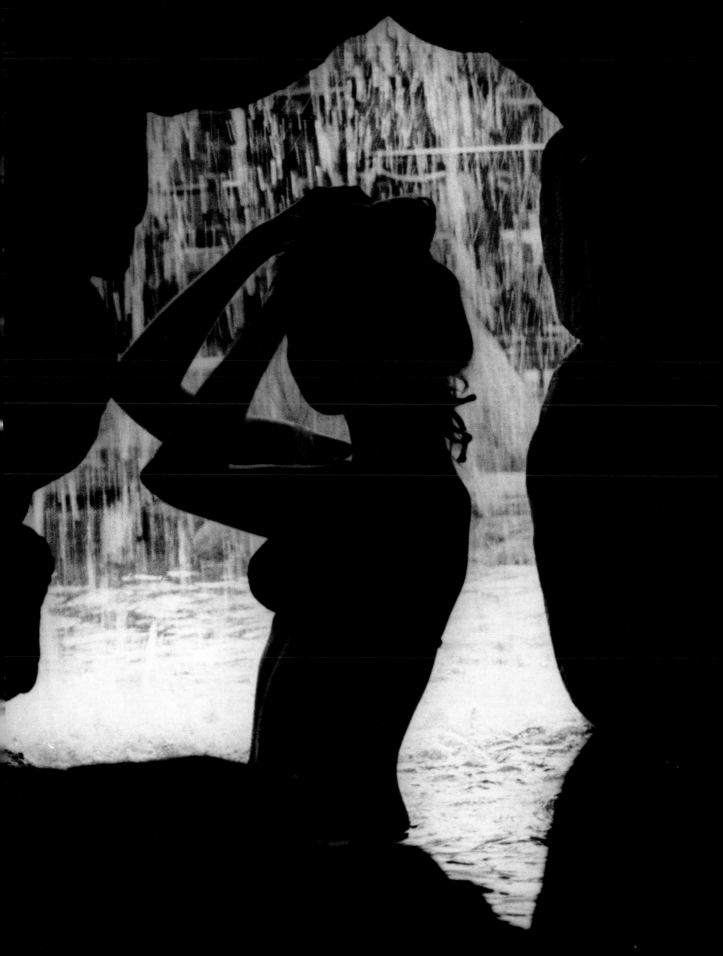

Isabelle Adjani |

Like a cat, she never blinks. Utterly mysterious and chimeric, Isabelle Adjani is truly one of God's (and France's) hauntingly alluring creatures!

Breathtakingly beautiful from every angle, she had this thing about being photographed head-on. She said she didn't like the way she looked, but I was convinced her reason was far more convoluted and primitive: I think she didn't want me to steal her soul.

It was as if she was dressed in veils. Like no other actor I had photographed, she appeared not to occupy her own body. Instead, she chose to exist only in some secret cranial location, more voyeur than participant.

Isabelle came by the house to look at all our material and she seemed pleased with what she saw, but she politely asked if she could "kill a few." Then, sitting on the floor like a little girl doing cut-outs, she proceeded to happily "kill" her slides into tiny pieces—actually singing to herself as she cut.

After she made confetti of the "fallen" images, she saved them in a plastic baggie—her party favor after a pleasant day at the beach.

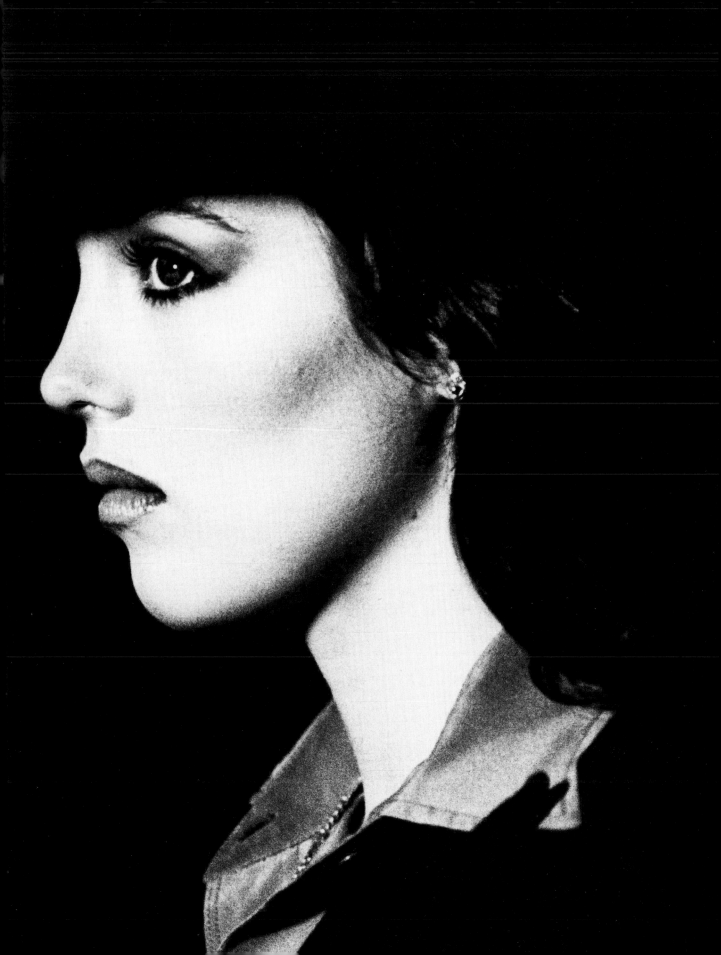

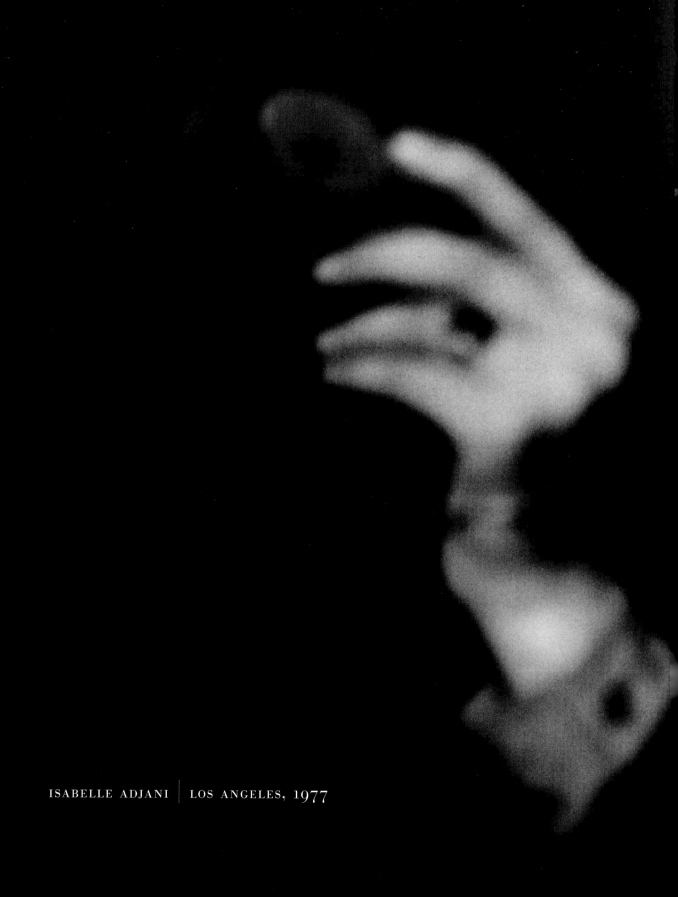

ISABELLE ADJANI | LOS ANGELES, 1977

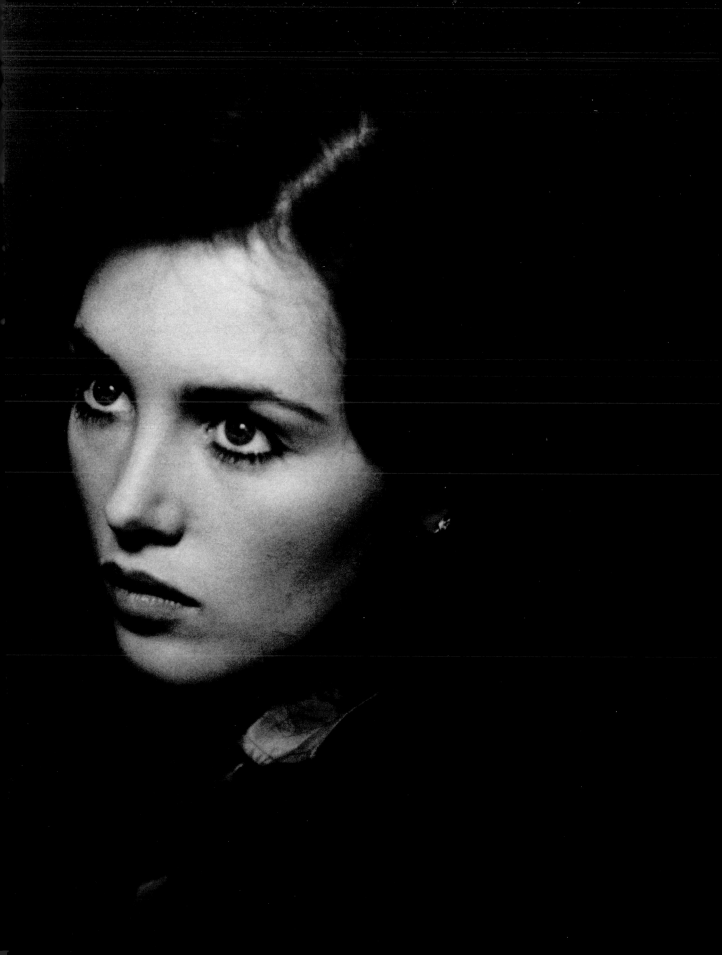

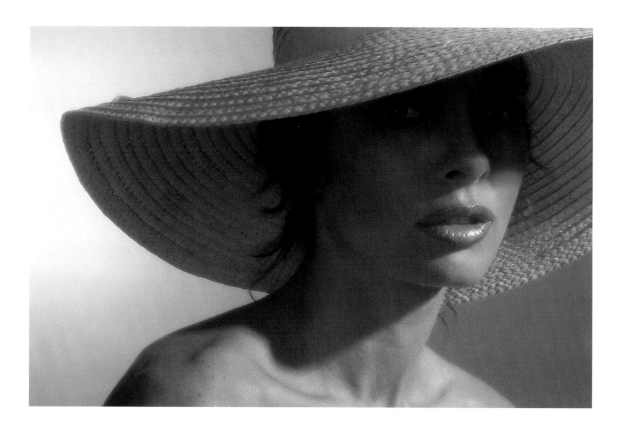

Anne Archer | MALIBU (top), 1982; MALIBU (right), 1982

Everybody thinks my friend "Annie Fannie" is a real lady. She walks and talks and certainly she acts like a lady, but I've always known better. When I photograph Anne Archer I "trash" her. I think tart; I think floozie; I muss her hair; I take off her clothes, and I focus on those big, luscious lips. And what do I get? Not a slut, but a totally sensual, gorgeous *lady*—the epitome of Anne Archer as I see her.

She gets cast as a lady/wife as well, but audiences, like me, see more in her. It was test audiences that demanded that she, as Michael Douglas's wife in *Fatal Attraction*, kill the evil Glenn Close (which gave her an Academy Award nomination). I would love to see her play an out-of-control, boozy, drug-addicted harlot—the Mr. Hyde to her Dr. Jekyll.

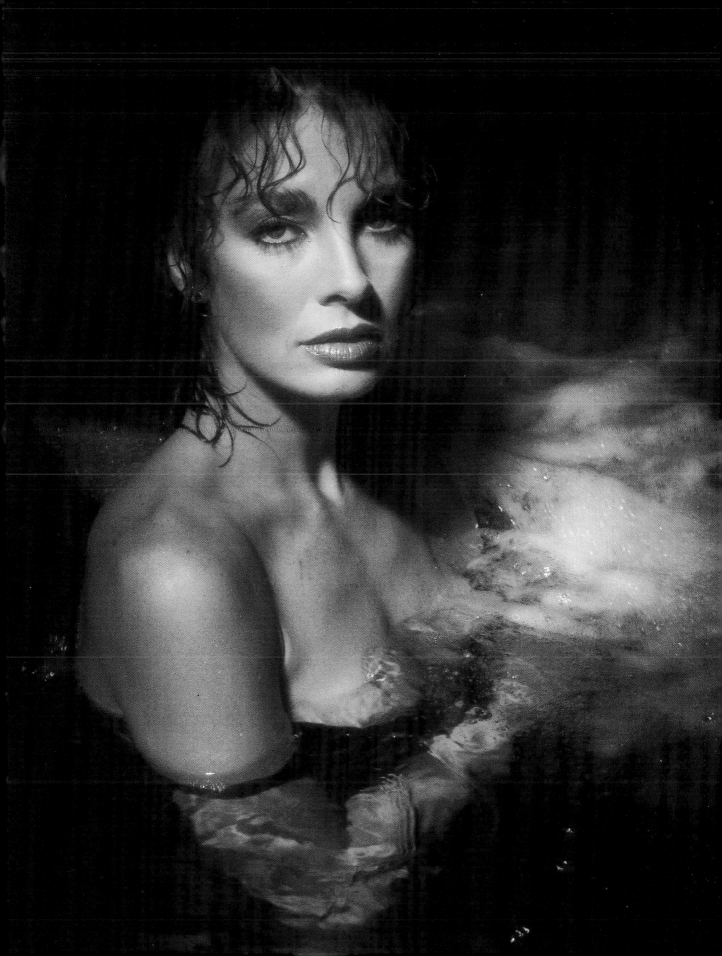

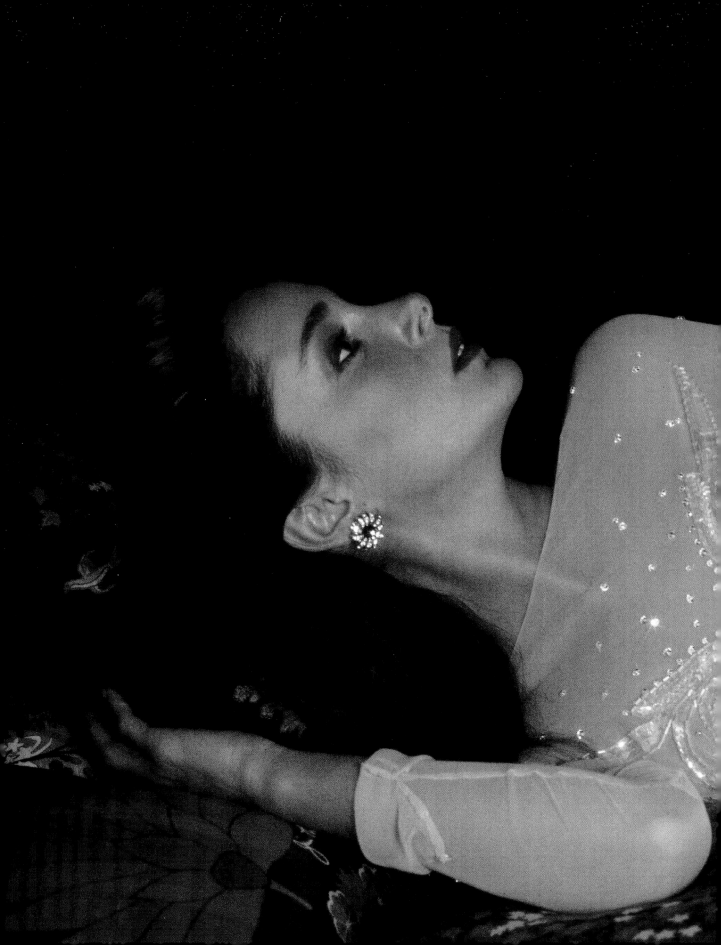

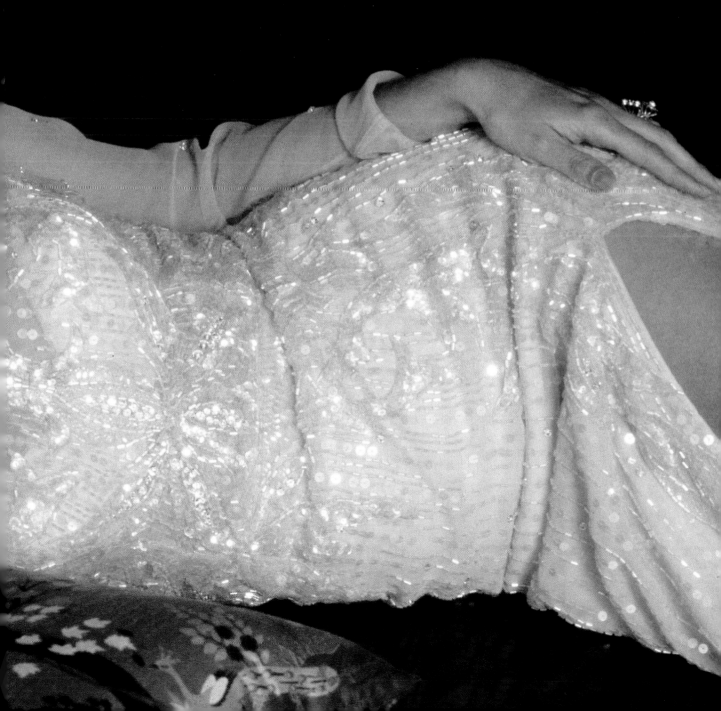

Pamela Bellwood | HOLLYWOOD, 1982

She should have been one of those luscious smoky dames that we discover in the shadows of Sam Spade's dingy office, for Pamela Bellwood was definitely one of those 1940s kind of gals. Instead she was Claudia Barrows Blaisdel Carrington in *Dynasty*.

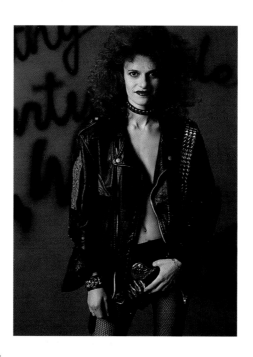

Sandra Bernhard | BEVERLY HILLS HOTEL, 1983

Sweet, polite—actually shy! (Who knew?) I was doing a story on the young, relatively unknown comedian who was about to be featured in Scorsese's *King of Comedy*. Though not exactly a conventional knockout, Sandra Bernhard had, I thought, an absolutely fabulous, sensual mouth.

Our first set-up was in her suite at the Beverly Hills Hotel where, in a moment of desperation, I fell back on to the pretty-in-pink/naked-in-bed/vulnerable-but-available standard, "innocent starlet," pose. (What was I thinking?) And *she* went along with it!

Fortunately, our next stop was at the Improv, the comedy club where she was appearing, and the innate, infrangible, perverse, and totally vulgar Bernhard emerged—free at last in her own habitat. (And that mouth!) By the time we hit my studio in Malibu, I knew what I wanted: I sprayed graffiti on seamless paper, intensified her make-up, and shot her as a Biker Bitch.

Had she not been so damn polite when we first met, I might have dispensed with the coy curls and pink blanket! On the other hand, I may be the *only* photographer who ever pictured her this way, and no, she didn't hit on me.

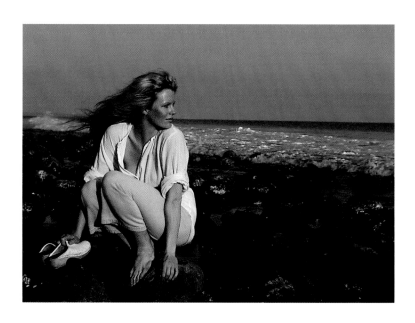

Kim Basinger | MALIBU, 1983

Yet another unknown luscious blond model-turned-actress who would soon appear in a Bond film (*Never Say Never Again*) only to fade away—the usual fate of those lovely but expendable 007 starlets. Well, not exactly!

Delicate, skittish, and somewhat distracted by her make-up man (and husband), Kim Basinger began our shoot as if it were just one more routine modeling assignment on the beach in Malibu. I looked through the lens and saw Ralph Lauren ads!

She was, indeed, beautiful, but *she* was not there. How could I get her?

Back in my studio, away from the scenery, it finally became about *her*. Alone, she exploded with a hushed sexuality—that "white heat" filmgoers have since come to relish.

Batman made Basinger a bankable star, *LA Confidential* gave her an Academy Award, but I loved her best opposite Jeff Bridges in *Nadine*.

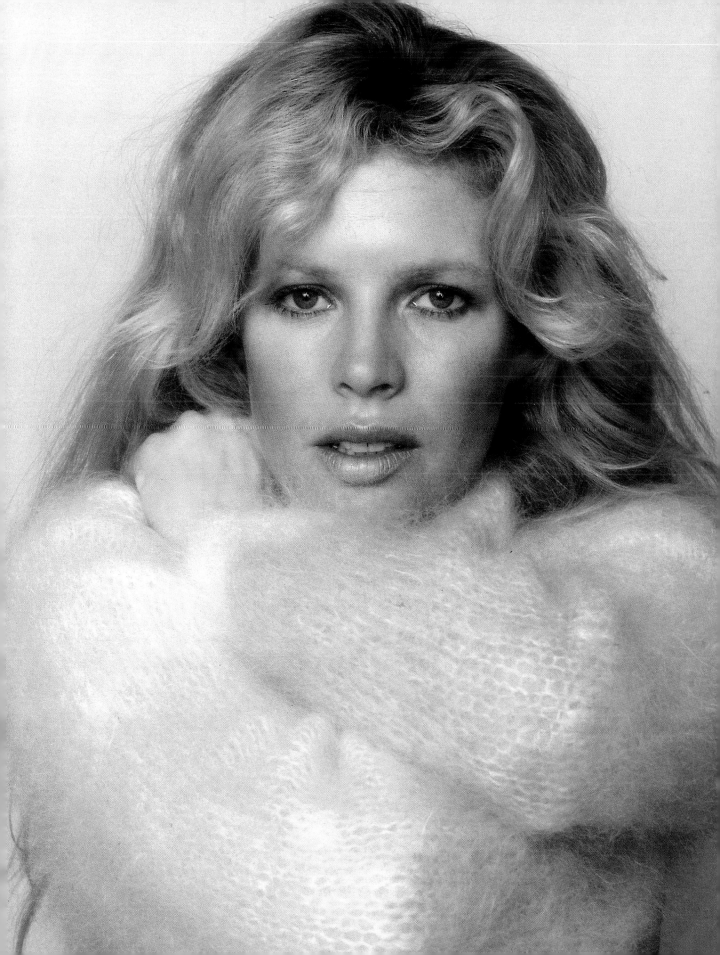

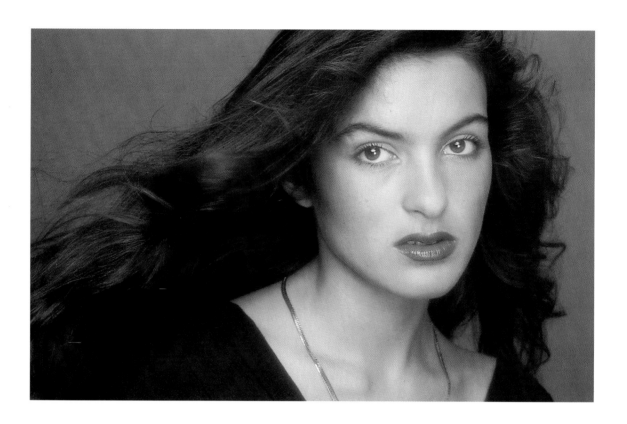

Mariska Hargitay | MALIBU, 1980, 1982

Don't get her started! Mariska's got the fast-talking, wise-cracking energy of a Catskills stand-up comic! She is the kind of person who knows her crew by name after a few hours on the set and keeps their energy high by being the court jester. So why is she so serene in front of the camera? I hear, but never see, the clown!

By the time she was sixteen,

magazines all over the world would be requesting material on her, for she was the beautiful young daughter of Mickey Hargitay and Jayne Mansfield. Wary of "too much too soon," Mariska took her own time. You can see her as Detective Olivia Benson in *Law and Order: Special Victims Unit*.

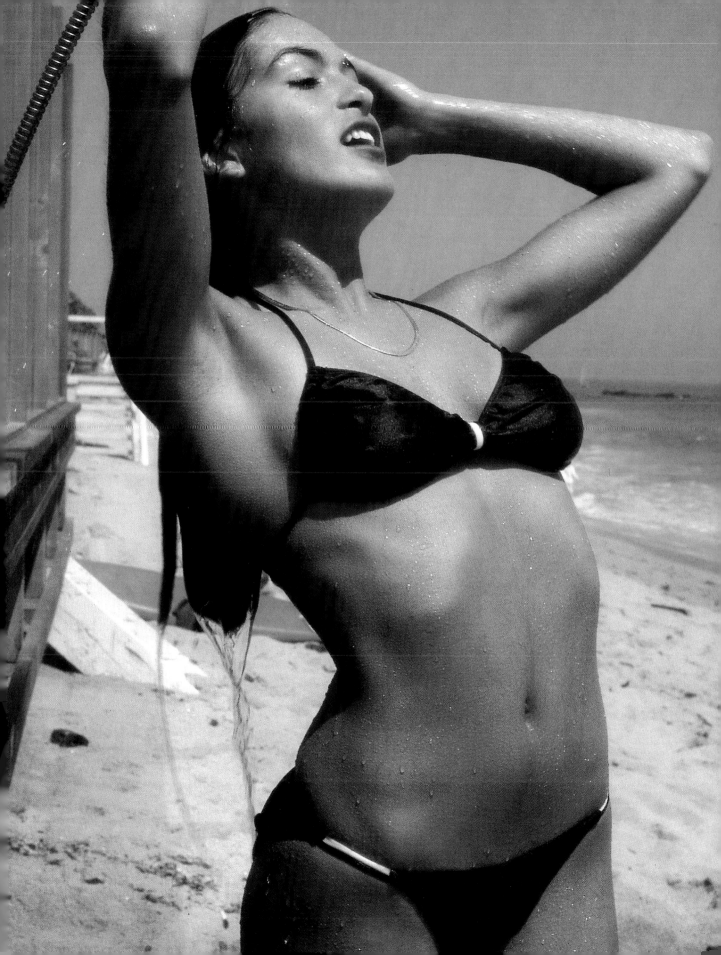

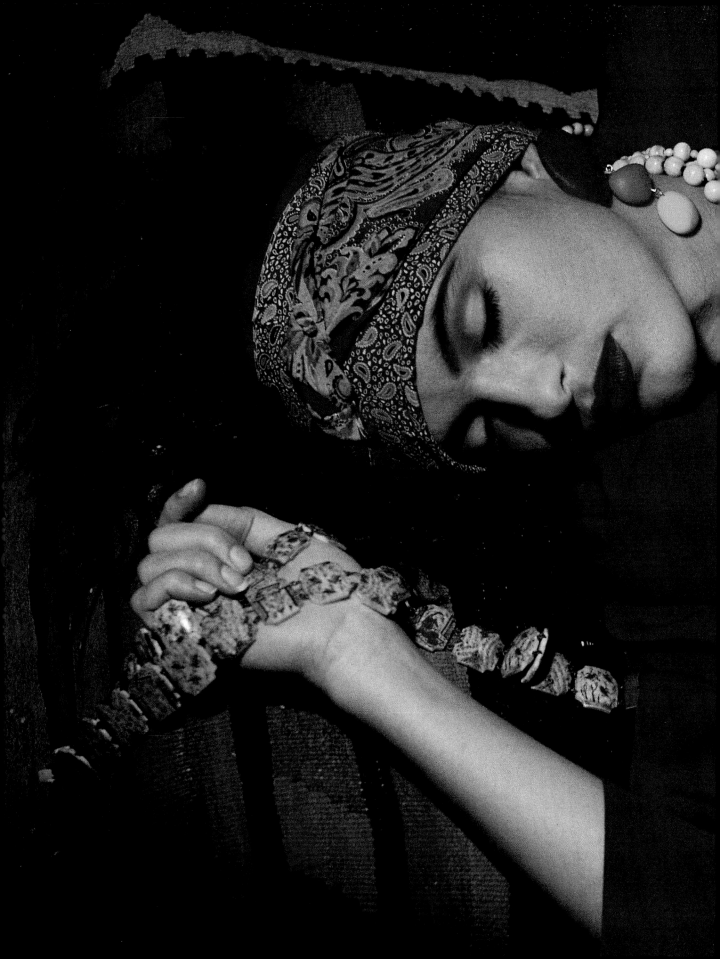

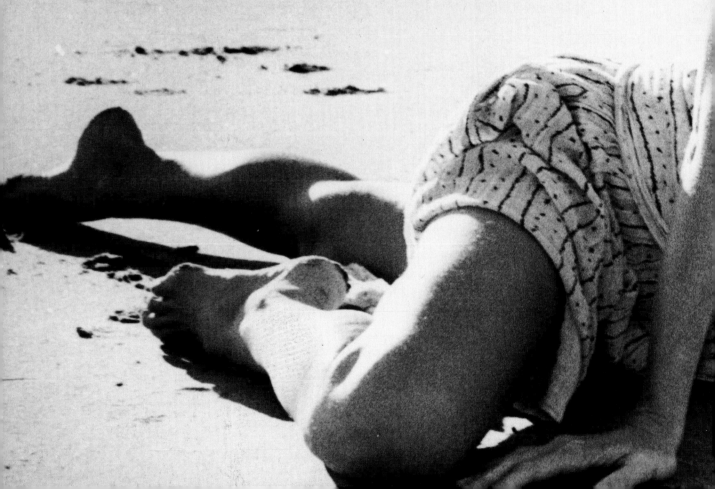

Kathryn Harrold |

Kathryn Harrold had been cast as Lauren Bacall in *Bogie*, but through my lens, she appeared more to be an earthy, sensual Sophia Loren. Crawling out of the surf seemed the primordial way to go.

She costarred opposite Luciano Pavarotti in *Yes, Giorgio*. It was to have been her breakout film.

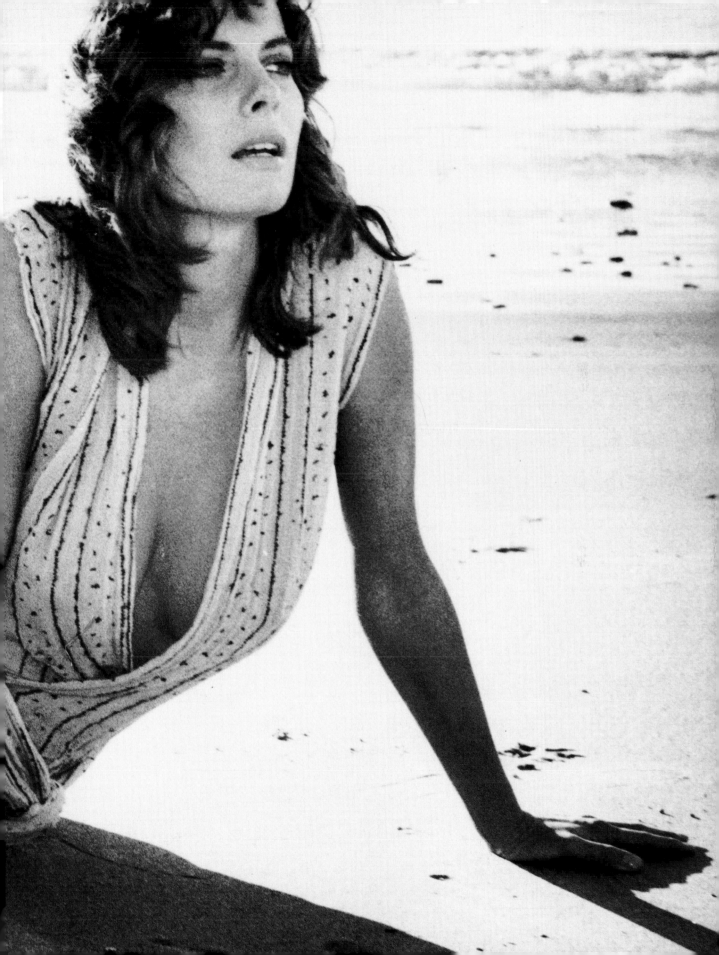

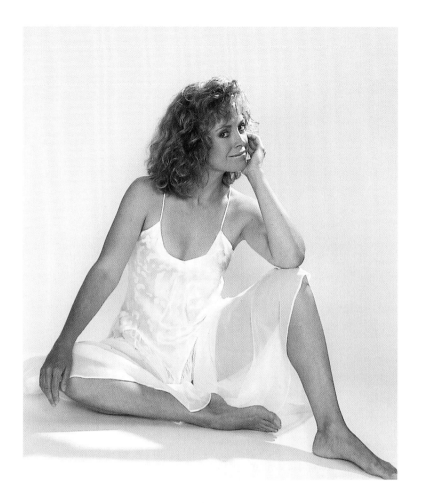

Catherine Hicks | MALIBU, 1985

"They like it when you're perky...."
Catherine Hicks is *the* All-American
girl. She *is* apple pie, picket fences,
and corn flakes! She may be naughty,
actually, she may get away with
murder, but "Mom" will love her!

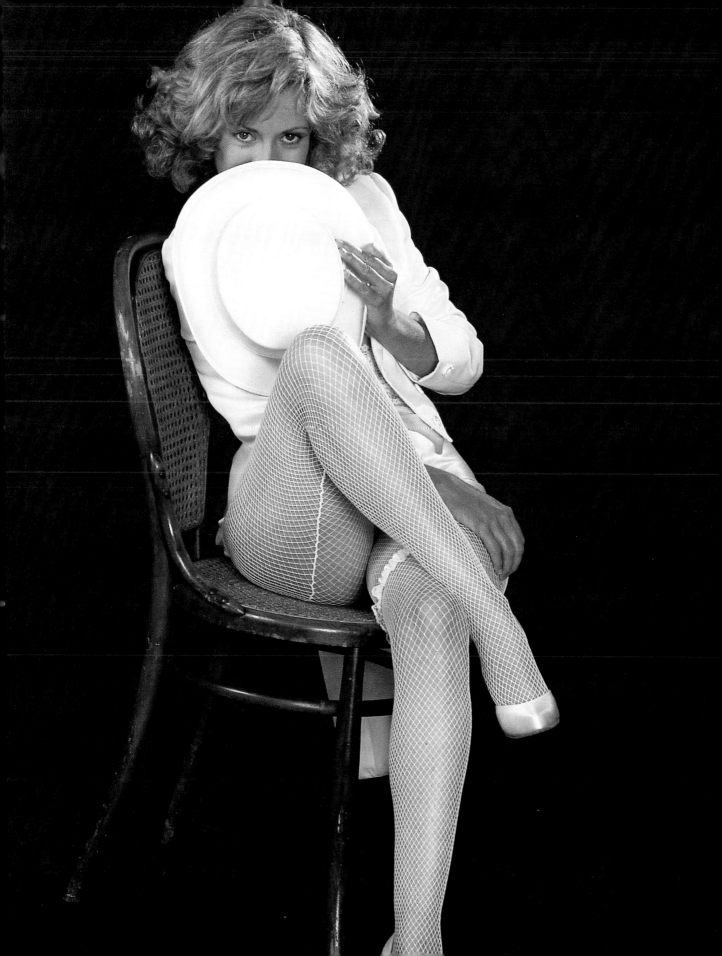

Isabelle Huppert | MALIBU, 1982

Already a star in France, Isabelle Huppert came to California to become a starlet! Her debut American film, *Heaven's Gate* (the other "gate" scandal) had become one of the most publicized flops in film history, and the public missed its chance to see Huppert at her award-winning best.

When Isabelle arrived in my Malibu studio, she looked like a Catholic school girl, but for the camera she became a vixen, smoldering with a dark sexuality.

Violette Noziere and *Madame Bovary*, her most noted (and awarded) films were for French director Claude Chabrol.

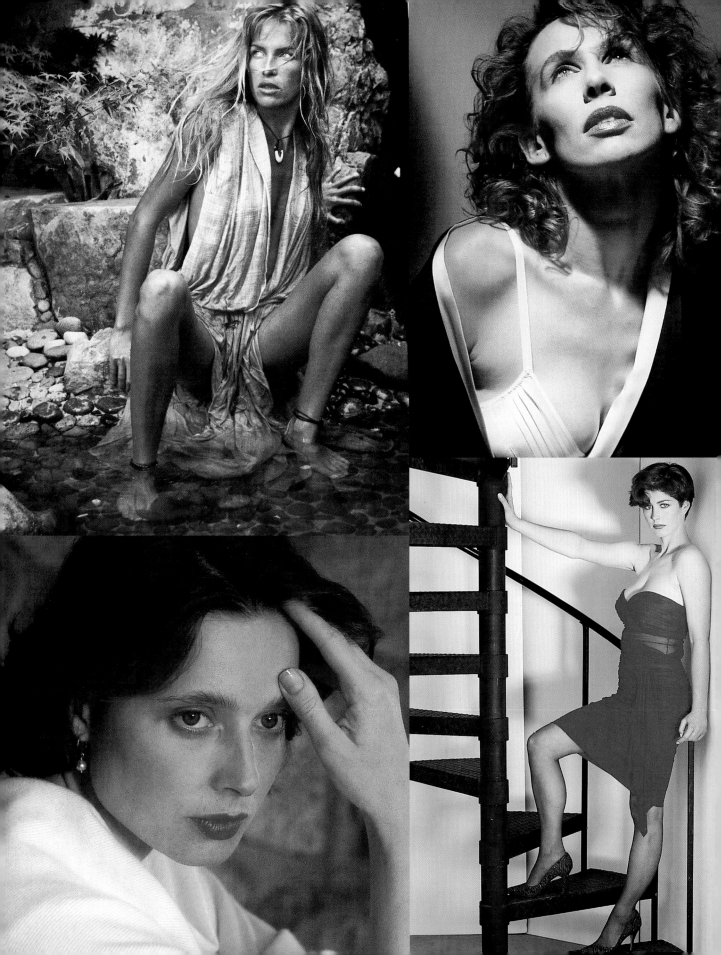

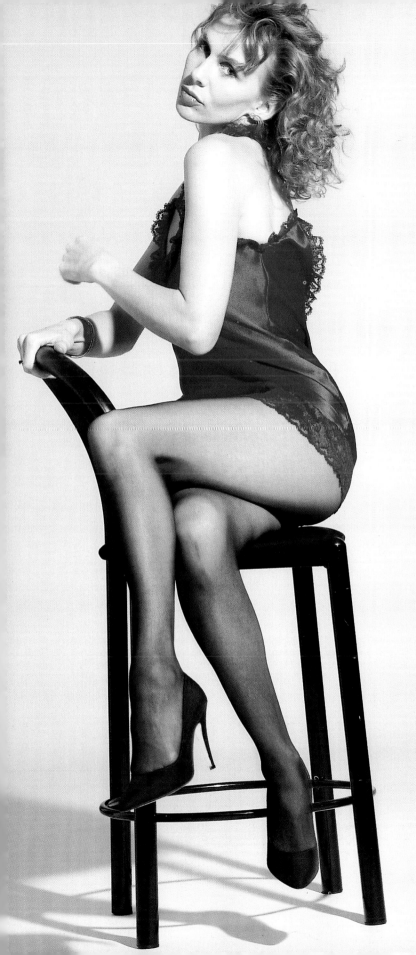

CLOCKWISE, FROM TOP RIGHT:
Trudie Styler, New York, 1989;
Dana Delany, Venice, 1990;
Isabella Rossellini, Vancouver, 1988;
Unknown

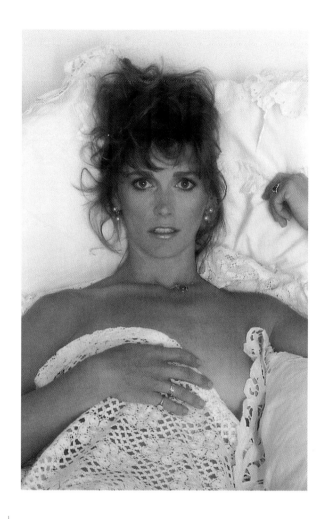

Margot Kidder | MALIBU, 1982

Margot, my friend and neighbor, became *us*—vicariously, all of us—as she flew through the skies by the side of her Superman. With that husky voice and spunky vulnerability, she was perfect for the part of Lois Lane: kind of sexy, kind of smart, kind of naive, not quite able to see that her dorky Clark was really the man of her (and our) dreams.

We shot a lot together. Our sessions always had a drop-in kind of energy—never rushed, never anxious nor pressured.

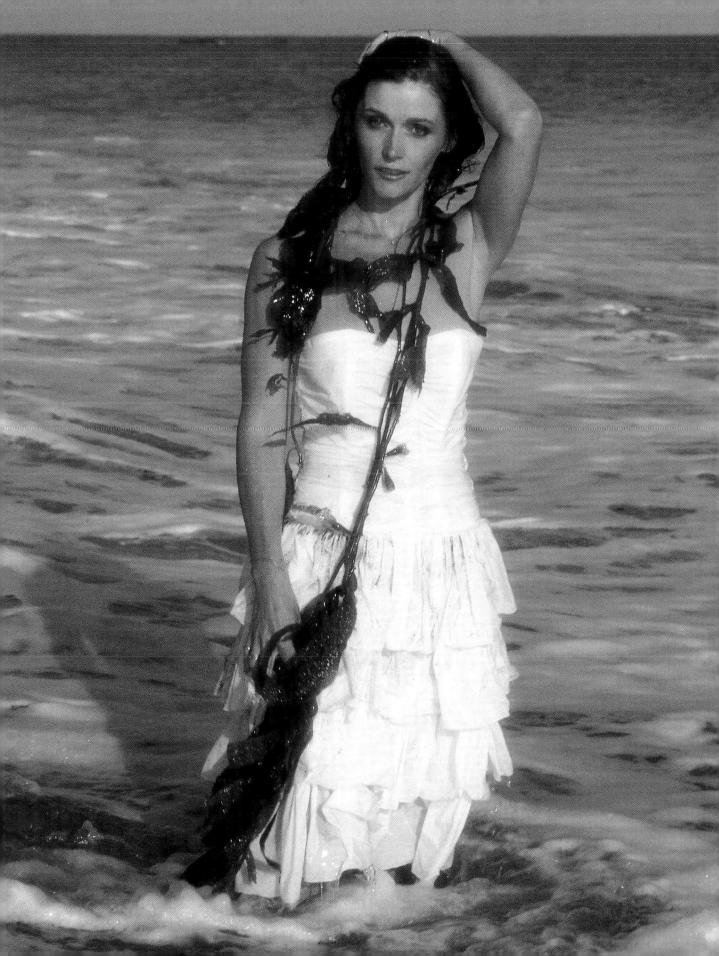

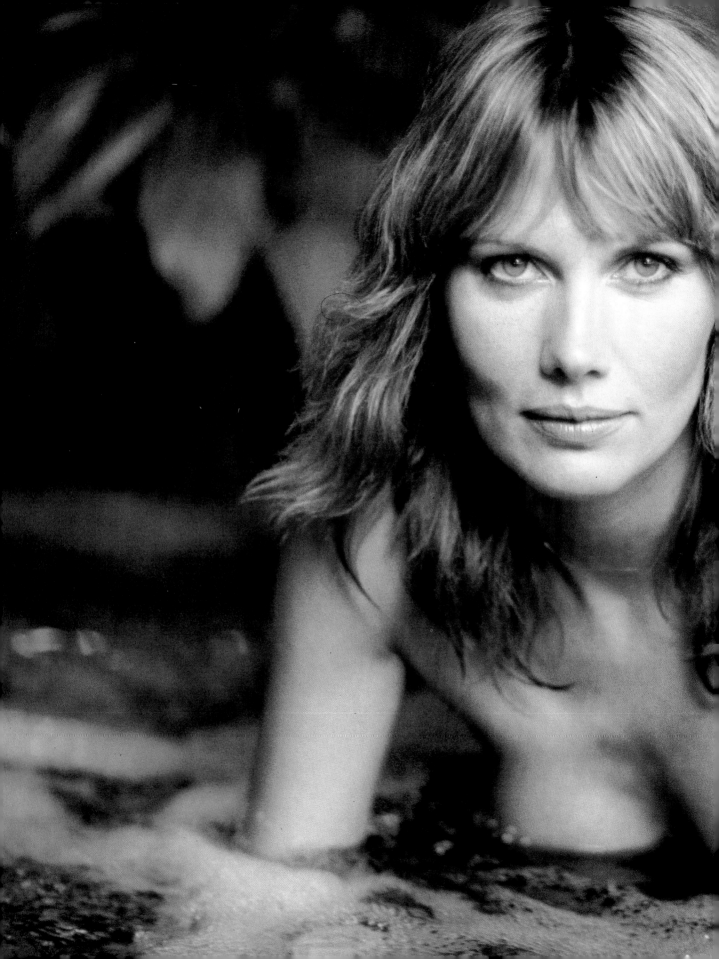

Maud Adams | MALIBU, 1980

If the Cheekbone Hall of Fame existed (why not. a Software Hall of Fame does!), Maud Adams. the icy calm Swedish supermodel and actress, would be a charter inductee. She was a photographer's dream: perfect from any angle, but also smart. She took the high-fashioned gelid gaze of the seasoned model and refocused it to that of the seductress—the starlet in control—allowing us to observe her. but daring us to draw closer. It was this languid but challenging quality that put her in the James Bond Hall of Fame as the *only* 007 girl that starred in two Bond films: *The Man with the Golden Gun* and *Octopussy!*

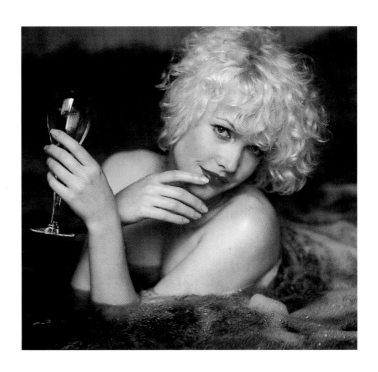

Linda Kerridge | MALIBU, 1980

"In fact, with the exception of the actress who plays the Marilyn Monroe look-alike, every character in the film is annoying, obnoxious, loud, selfish, mean-spirited ..." so wrote an on-line user commenting on the horror film *Fade to Black* (1980).

Well, that same "Marilyn" came to Malibu for a photo session. What I remember most about Linda Kerridge was her sweet delicacy: pale, pale skin, pale pink lipstick, and floppy platinum curls. She had an "overexposed" quality about her, as if light came from her rather than toward her.

She went on to do *Mixed Blood*, *Vicious Lips*, and *Alien from L.A.*, which was released in 1987. It appears to be her last film.

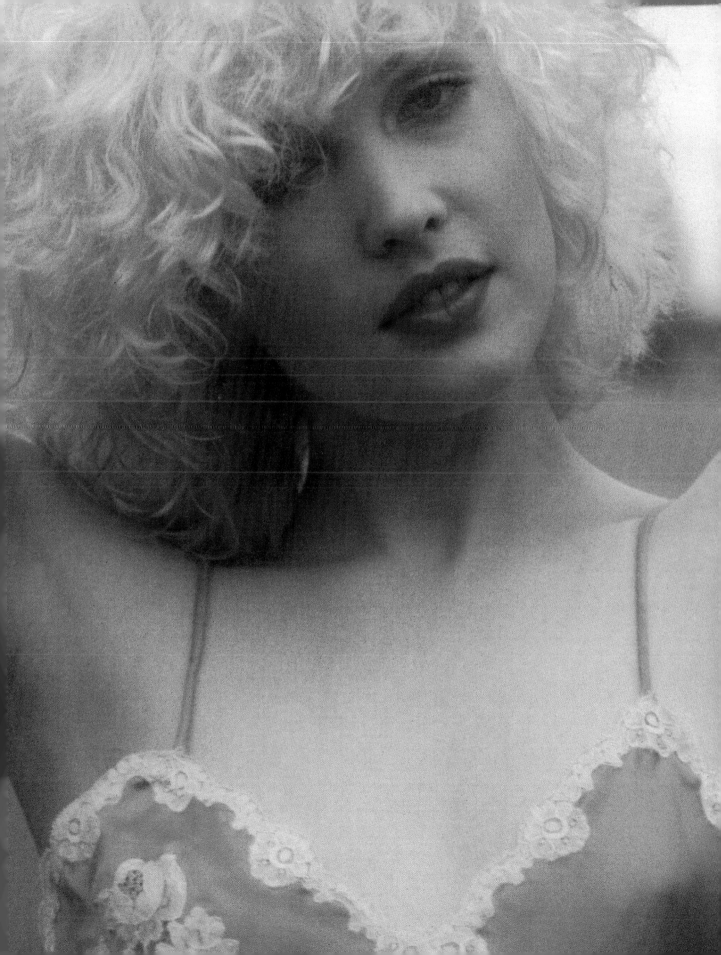

Janet Jones | MALIBU, 1987

Athletic and fit (she kickboxes), Janet Jones began her film career as a dancer in such films as *Annie* and *Staying Alive*, and she didn't go unnoticed. She was cast as Judy Monroe in *A Chorus Line* in 1985. Shortly after its release, I photographed her on location in Sierra Retreat. She was bubbling with excitement: a new boyfriend—kind of famous, could I keep a secret? Yes.

Janet had a strong sense of herself and of her personal boundaries. She wasn't as hungry as some others, and while she continued to work, I think she will best be remembered as the beautiful Mrs. Wayne Gretzky seen regularly on TV during Ranger games.

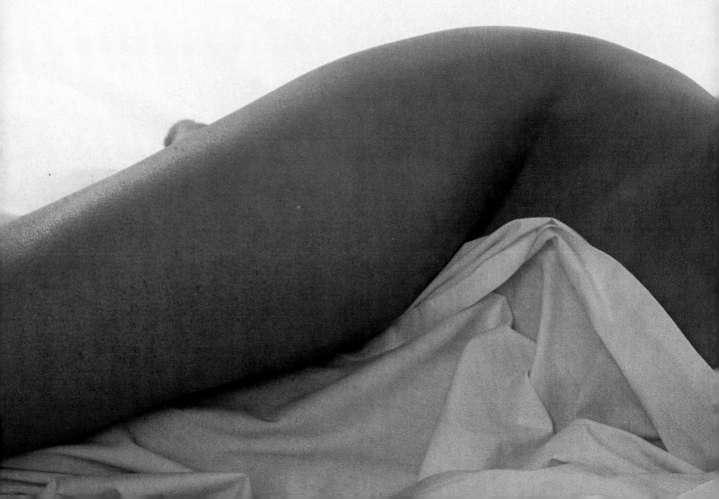

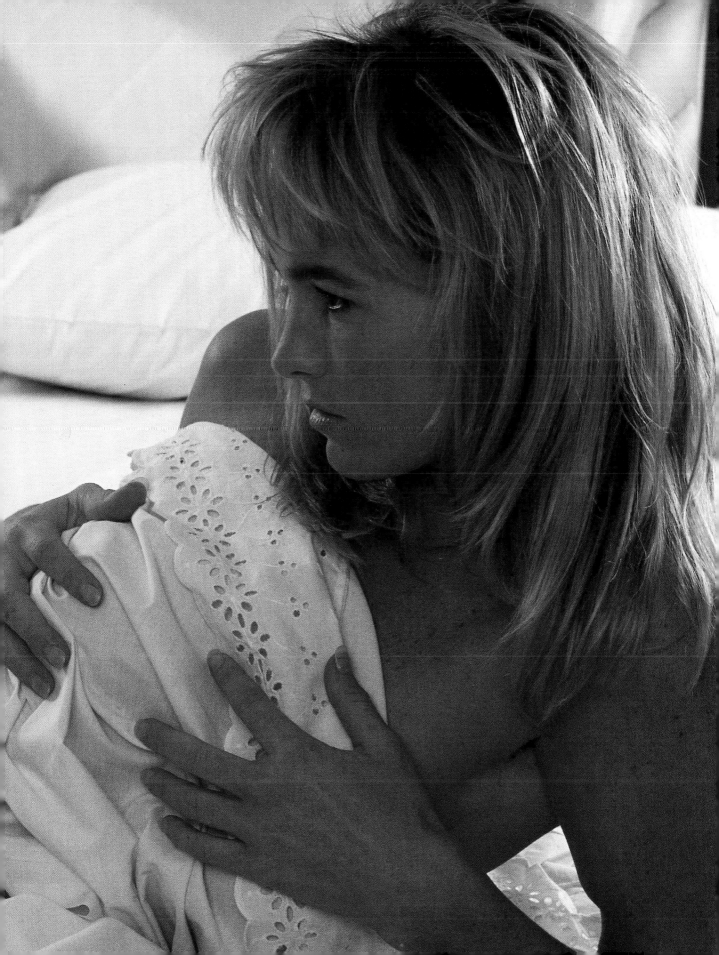

Heather Locklear | MALIBU, 1982

Dynasty fever! I was doing a story on all those sexy babes from the hit show, *Dynasty*, for a British magazine. A two-shot of Linda Evans and Joan Collins—the stars—was to be the cover, but the editors hadn't seen the selects on twenty-one-year-old Heather Locklear! Hello! She was the perfect sunny, blonde Californian starlet ... and still is!

For the last two decades, we have been allowed to marvel at how Locklear continues to be the complete embodiment of our starlet fantasies.

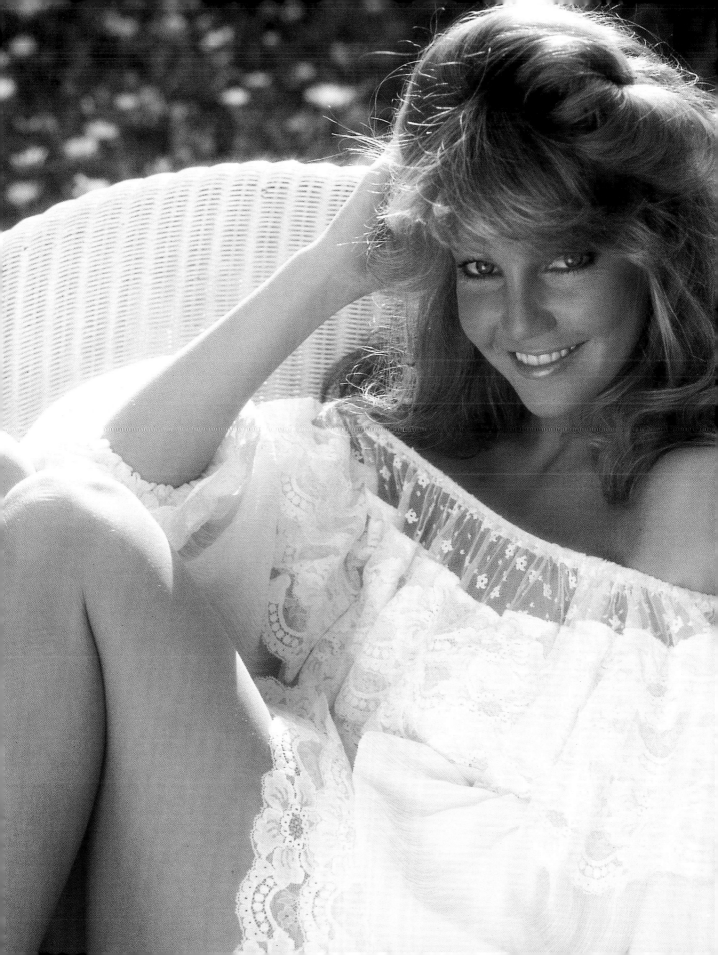

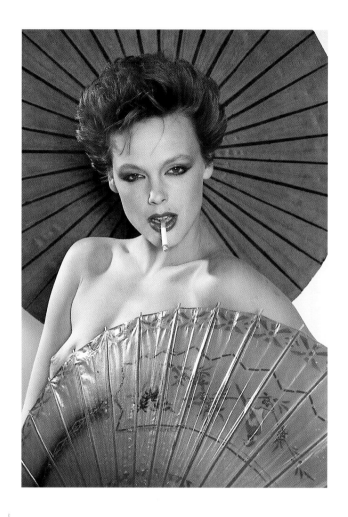

Brigitte Nielsen | MALIBU, 1985

A hoot to shoot! Not only was Gitte outrageously playful and drop-dead gorgeous, she kept us all in stitches with bits of juicy gossip about her love life.

The downside, of course, was that my hot-blooded young (male) crew was nearly useless, beguiled by the very *bare* beauty of this 6´1˝ Danish goddess! (Ah, come on guys— we're working!)

Her first film, *Red Sonja*, starring Arnold Schwarzenegger, had just wrapped, she had a new boyfriend, Sly Stallone, and the world was her oyster.

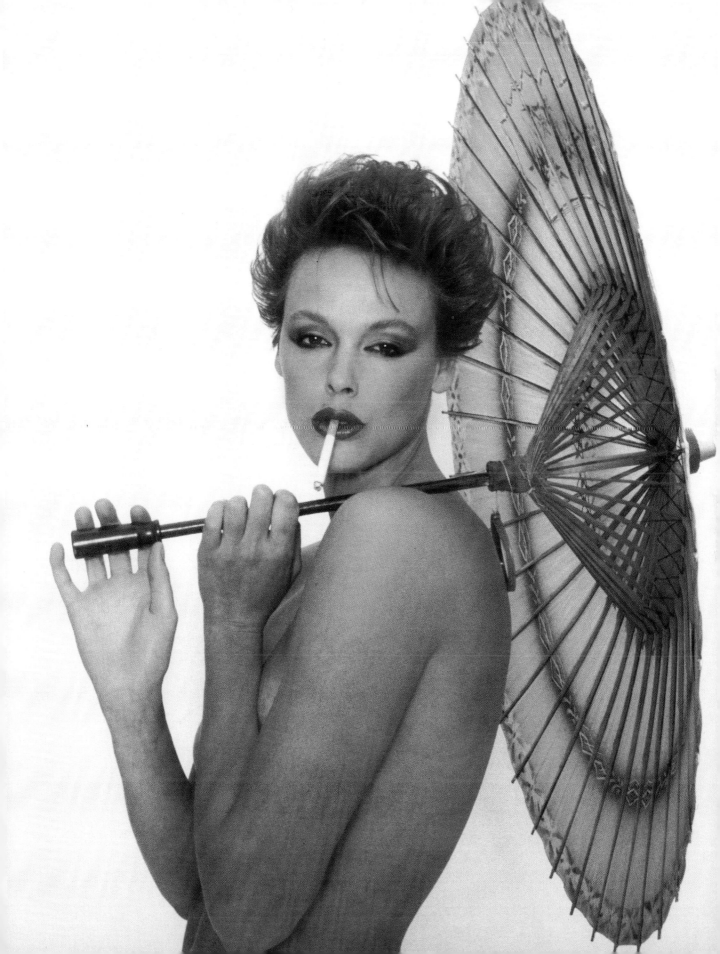

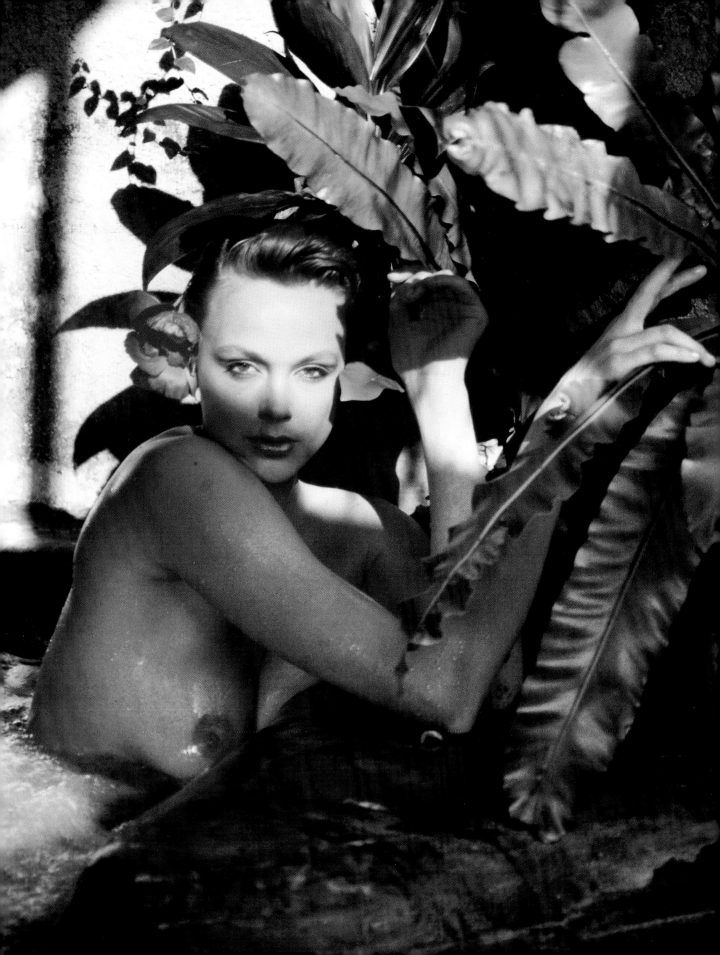

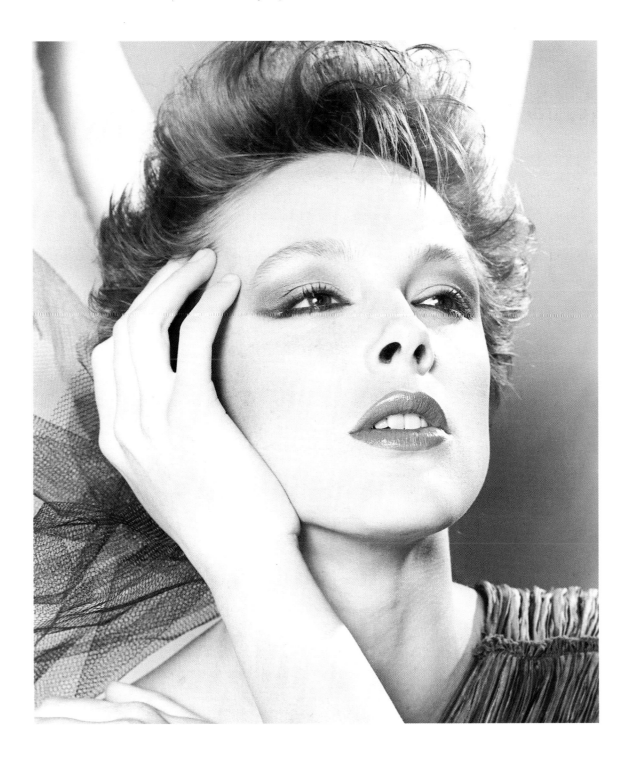

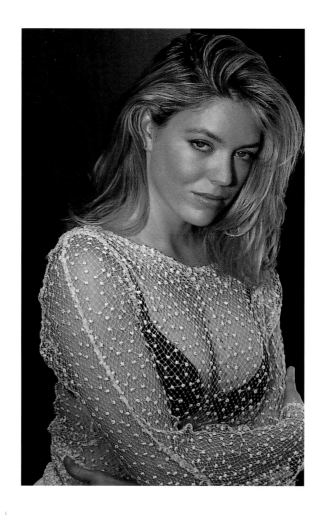

Leilani Sarelle | VENICE, 1991

Basic Instinct was just wrapping, and word of mouth from the set was hot. It was to be Sharon Stone's breakout movie and Leilani was playing Sharon's lover, Roxy. She would be noticed! (Actually she was noticed earlier playing the highway patrol officer in *Days of Thunder*.)

Leilani had a very placid, calming presence—so much so that I was worried she was too passive and that our session might lack visual energy. Wrong! On film she was all sex and intensity—I actually had trouble finding kills.

She married actor Miguel Ferrer later that year, and though she continued to work, I think she found her family life more fulfilling.

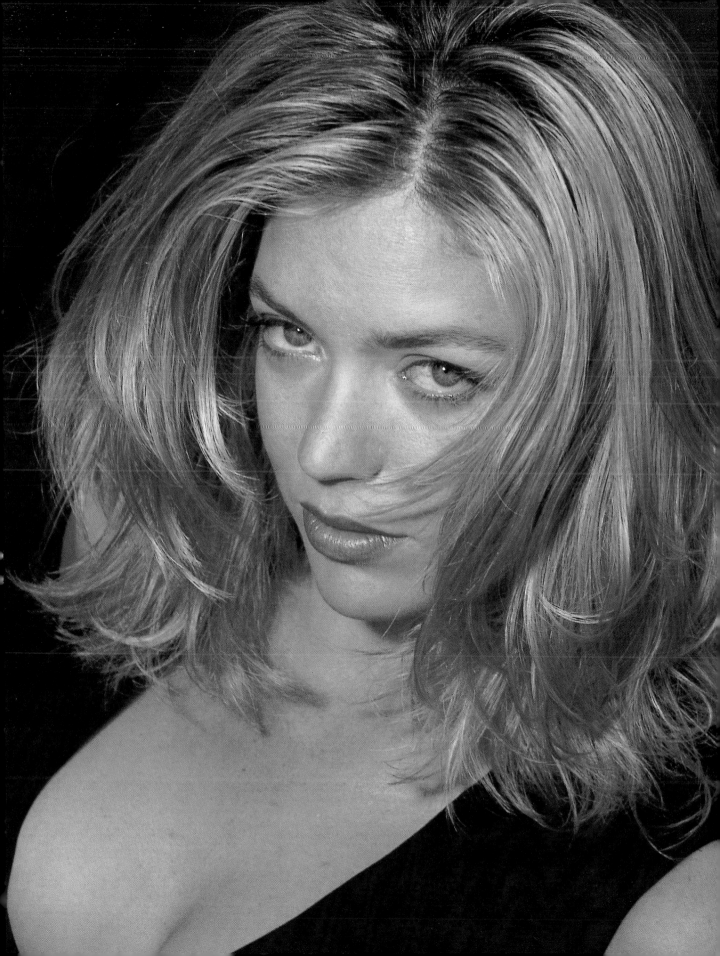

Sharon Stone |

Sharon and I had fun working together in Mexico on *Total Recall*, and Sharon suggested we do another session back in California after the film wrapped.

She arrived at my Venice studio with wondrous outfits and props, which she had styled herself. She knew exactly what she wanted to do and I happily went with the flow. Sharon became a studied goddess in the old Hollywood style. She took all that nostalgic glamour, coupled it with an inventive, hip, and sometimes shockingly ambiguous sexuality, and produced herself as an icon. That day she became one of my favorite models.

During a later session just before the release of *Basic Instinct*, we were horsing around on the Venice boardwalk, laughing and being silly. She was having a great time interacting with everyone while I took photographs. "Enjoy the moment," I said. "You'll *never* have the opportunity again once they see you in *Basic Instinct*." She was startled. She knew she wanted to be a star, but she had no idea at what price.

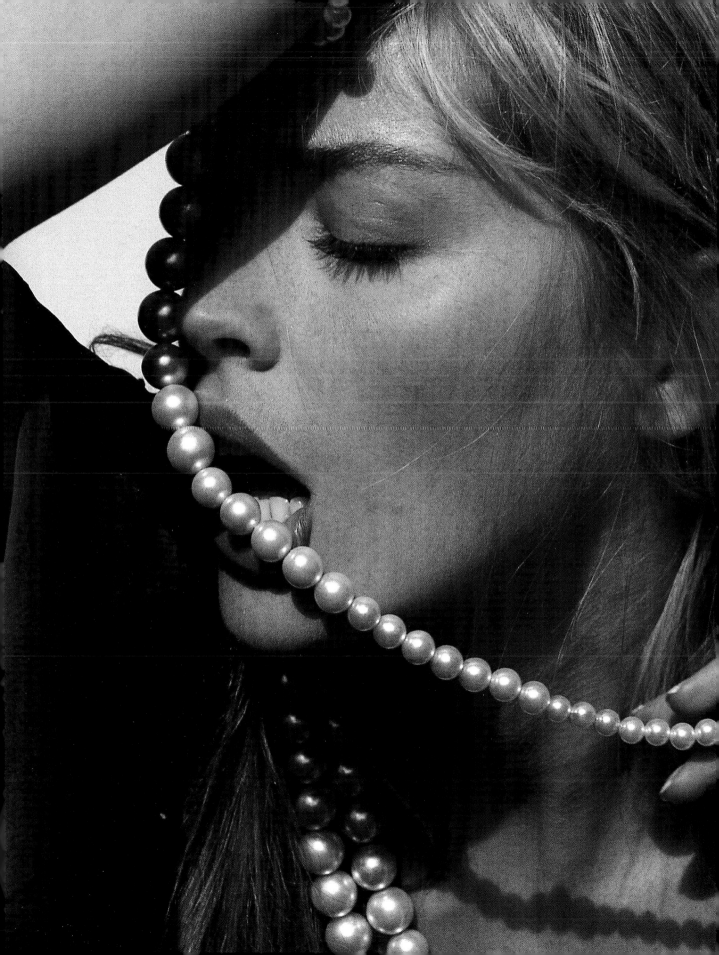

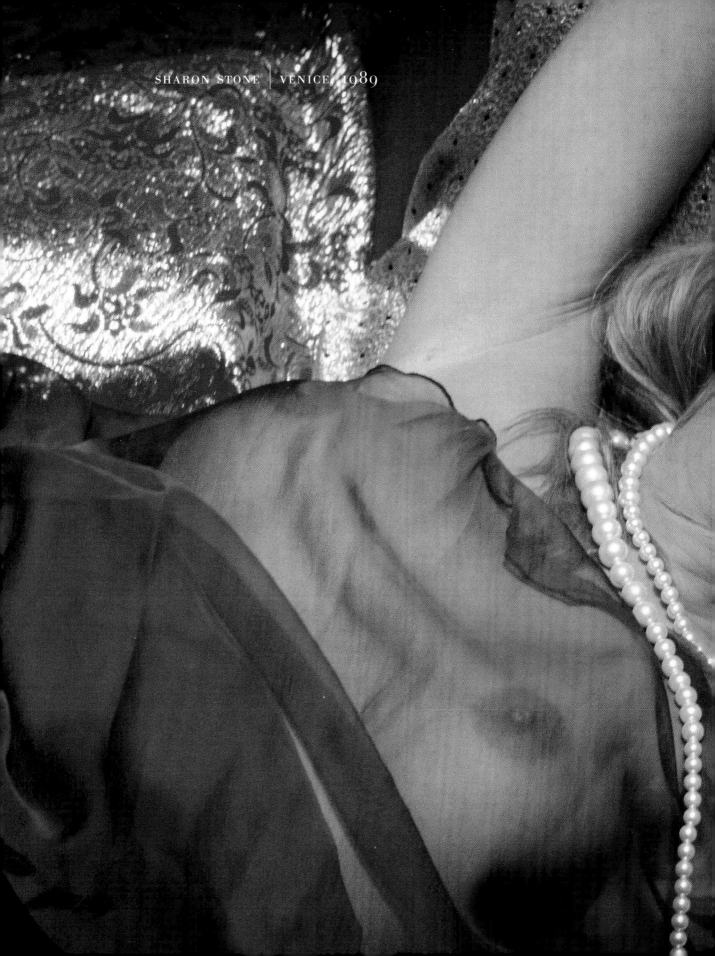

SHARON STONE | VENICE, 1989

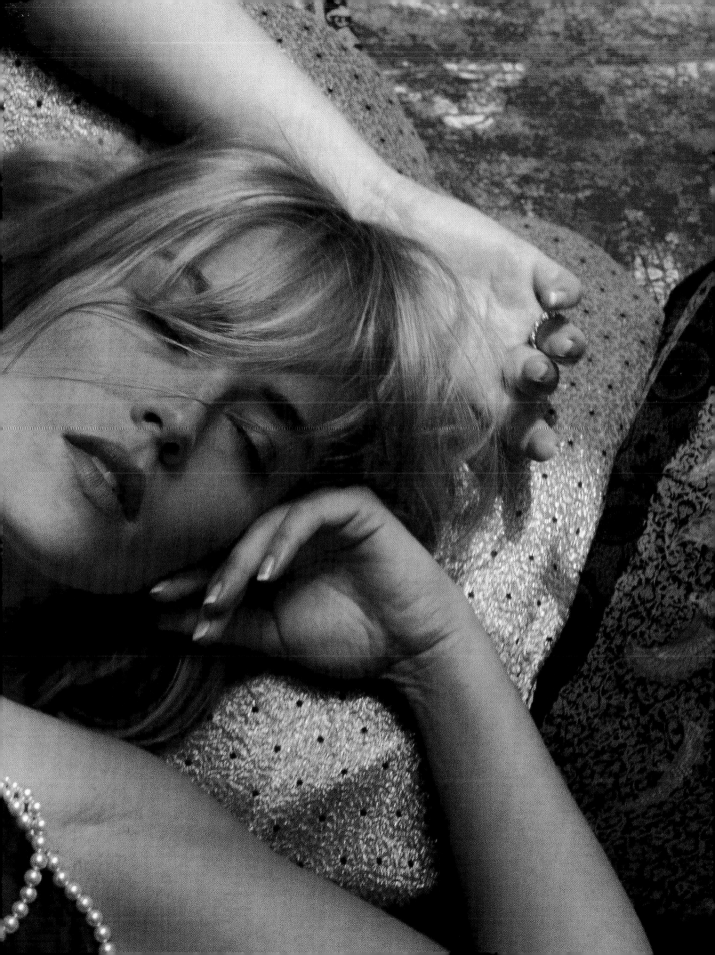

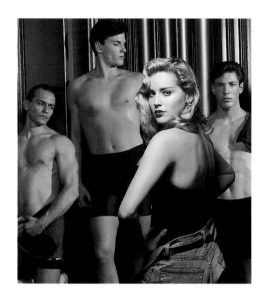 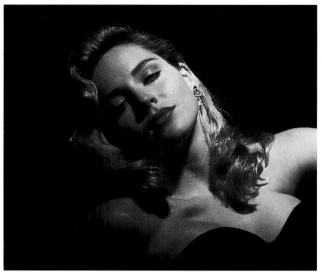

SHARON STONE | MEXICO CITY (left), 1989; VENICE (right and opposite), 1989

When I was on location in Mexico City shooting *Total Recall* starring Arnold Schwarzenegger, as special photographer, I was expected to produce usable material both on-set using their sets and lighting, and off-set where I create my own studio set-ups. When it was time to shoot off-set I was given a call sheet which read, "Douglas Quaid's wife, Lori—Sharon Stone." I didn't recognize the name, so I was completely unprepared for what was to follow. Though unknown, Sharon had all the impact of a superstar! Predicting stardom for her—in my mind—was a slam dunk. What I didn't know was that it had taken her a decade of toiling in the fields of B movies and bit parts before she would be noticed. Hard working ("Second only to James Brown," she used to quip). Director Paul Verhoeven may have made it all happen, but it was her tenacity, intelligence, discipline, and driving ambition that kept her going when others would have fallen by the wayside.

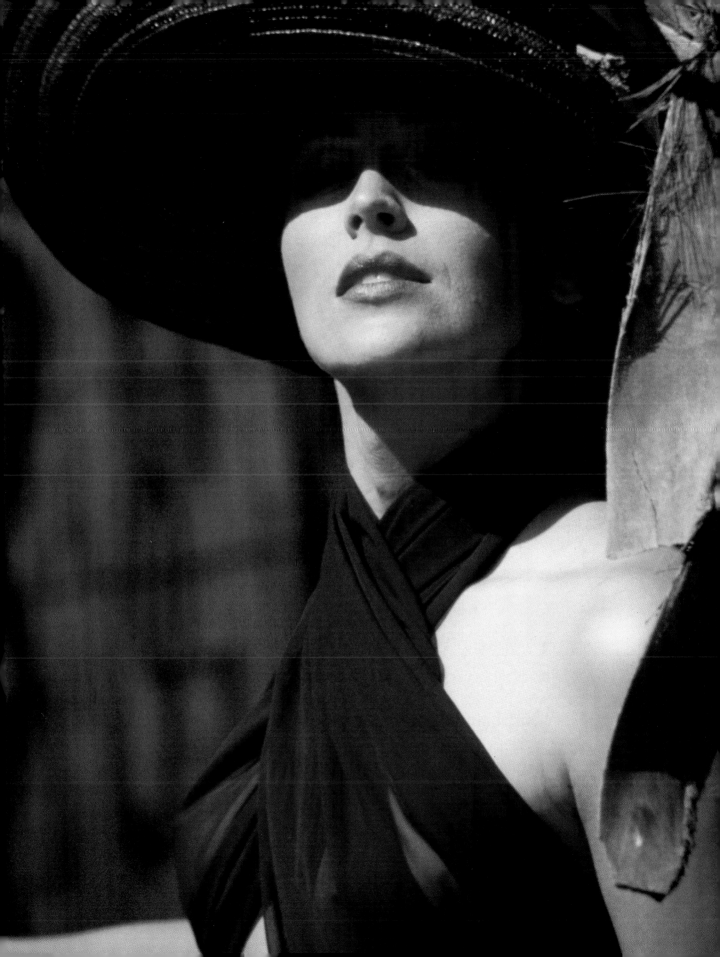

Glenn Close | MALIBU, 1982

The World According to Garp had just opened, and a thirty-five-year-old Broadway veteran named Glenn Close was playing Robin Williams's mother(!) and she was perfect! I *had* to photograph her.

My "starlet" arrived in Malibu, bearing a very un-Hollywood face and style—more like your preppy East Coast roommate from boarding school—and the clothes and accessories that were provided for the shoot were a disaster (someday I'll show you the portraits with the tricorner hat). I got nervous—actually, I was in a quiet state of terror. How would I shoot her?

She soon reappeared in make-up looking absolutely radiant. But the clothes! In desperation, I threw her in a baggy coat and we went for a walk down by the lagoon. She became inspired, and immediately morphed into Meryl Streep as *The French Lieutenant's Woman*. Finally, we were forced to return to my place and to *the clothes*.

She picked out a really "practical" double-knit suit (Oh no! Not the practical double-knit suit!). I grumpily set up the scene and she primly took a seat, morphing this time into a sweet but slightly awkward "proper" lady. She then did a ten-minute nonstop monologue (in pantomime) about a woman during a job interview explaining that while she had no secretarial skills, she'd be more than willing and quite adept at "putting out." I found myself without assistants; they were literally rolling on the floor, crying with laughter.

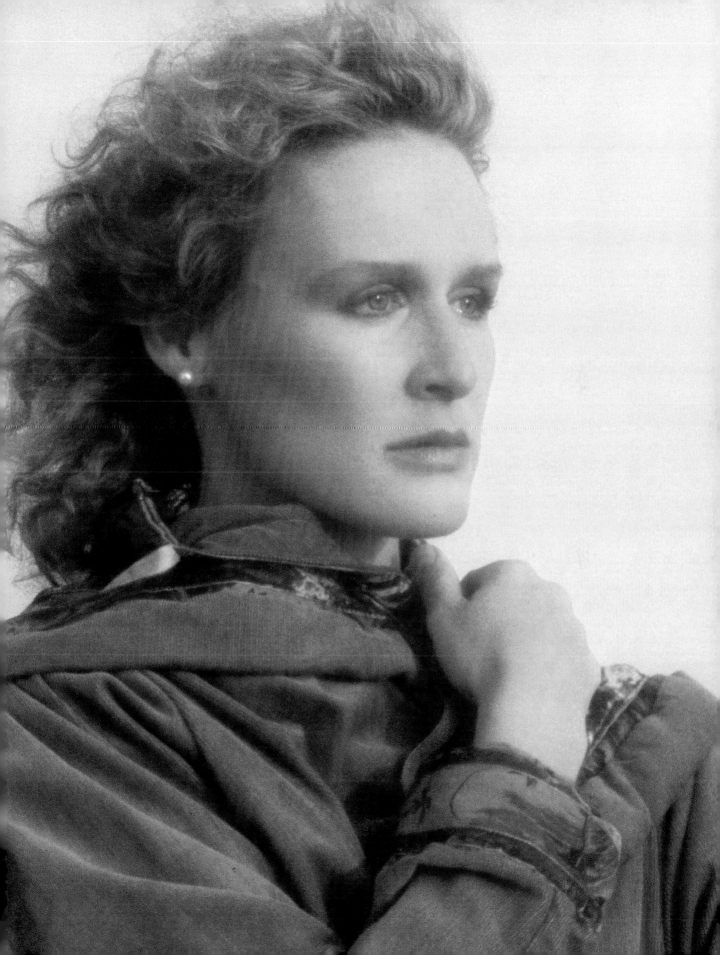

JoBeth Williams | MALIBU, 1982

In 1979, JoBeth Williams, making her film debut as Dustin Hoffman's one-night stand in *Kramer vs. Kramer*, definitely caught our attention when she was seen naked darting down the hall (remember?). Well, with her clothes on (which is how I shot her), she was very brassy—like all those dames from the 1940s who were described as "sharp cookies!" So I shot her observing *us* instead of the other way around.

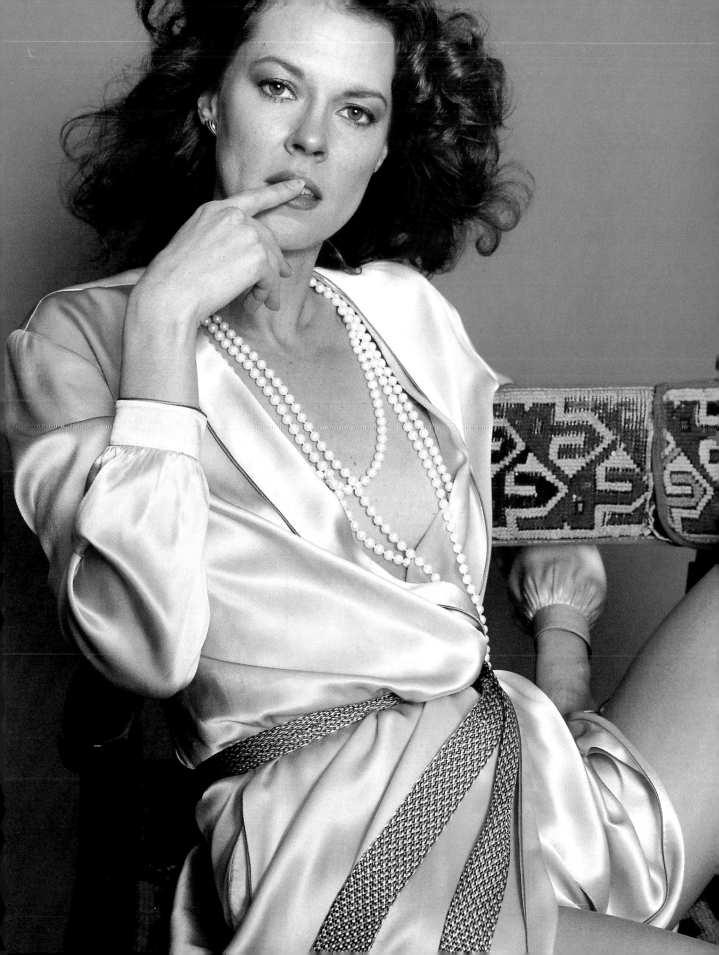

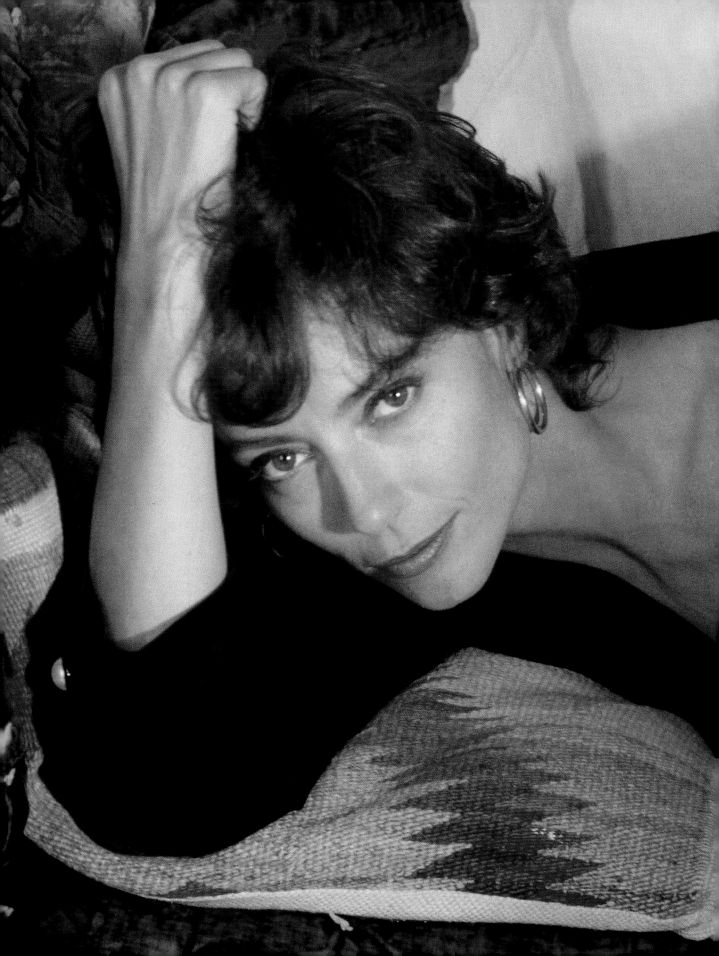

Rachel Ward | VENICE, C. 1989

I met Rachel during the making of *The Thornbirds*. She had just dazzled filmgoers as Dominoe in *Sharky's Machine*, and she was about to do the same to her costar and future husband, Aussie hunk Bryan Brown.

Rachel is actually more beautiful without makeup. Makeup is meant to conceal blemishes, but in Rachel's case its artificiality conceals her character. With that swanlike neck and that gloriously elfin yet sometimes imperious face of a naughty child, she willfully turned her back on stardom at the height of her popularity and moved to Australia. Now, when anyone wants her, they have to track her down.

Marina Gregory | <small-caps>Venice, 1987</small-caps>

Daughter of Andre Gregory, Marina came to Hollywood, I think, more out of curiosity than yearning ambition. Our photo session was a lark for her. She and a friend had just seen *The Unbearable Lightness of Being* and she was inspired. An "Unbearable Dance" was improvised for my camera all in great fun. What I saw instead was Delacroix's heroic Liberté (in cowboy boots!) emerging from the smoke of the French Revolution to lead her people—an image that must be one of the most gallant and powerful in the history of painting.

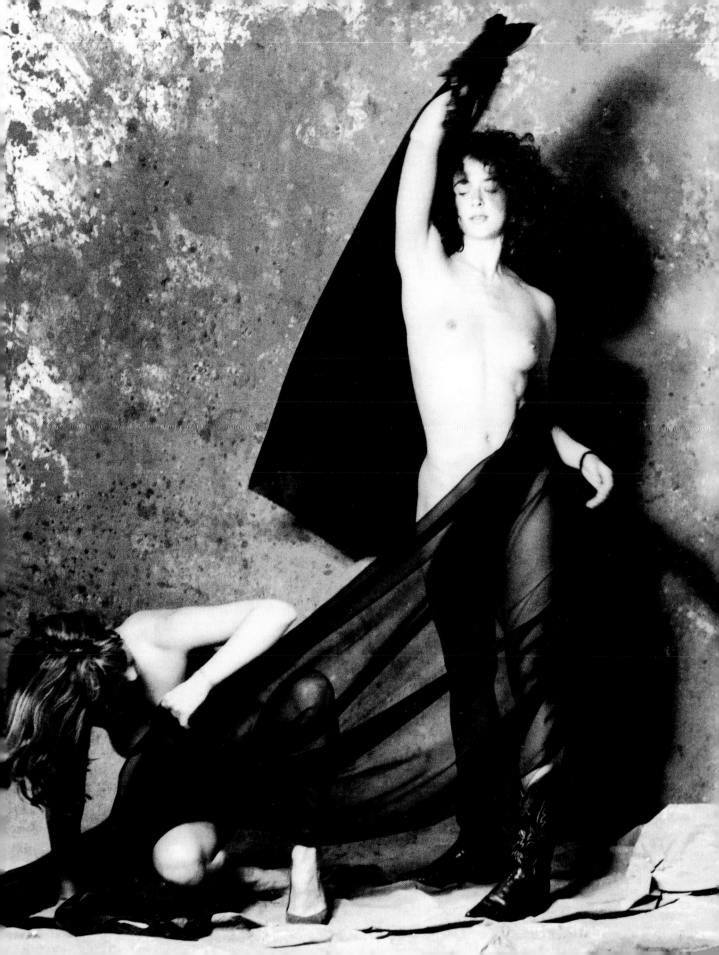

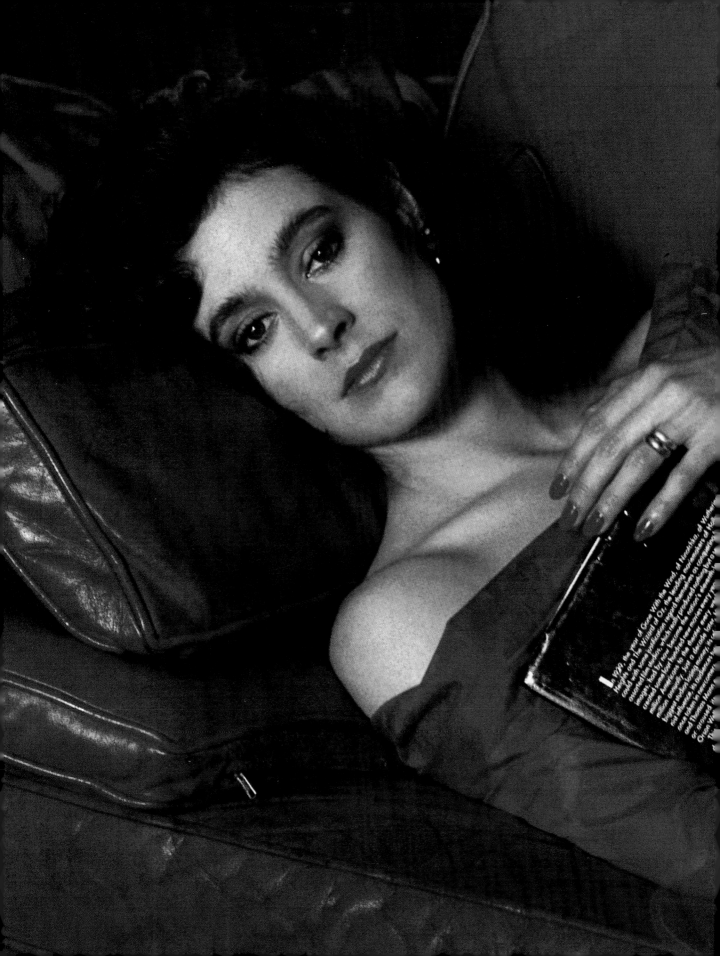

Sean Young | VANCOUVER, 1988

"I have P.M.S." (Translation: I don't want to be here; I don't want to be photographed; GO AWAY!) I'm on location in Canada, doing off-set portraits of the stars of *Cousins*, and I've just met Sean Young. "P.M.S.," I say. "That's great energy! We'll shoot how you feel."

Left with nowhere to go she did the session. It was okay, but when I found her between takes reading a book, Sean Young, who didn't have to do the photograph became mellow and gave me this luscious pose—like biting into a grape I thought at the time.

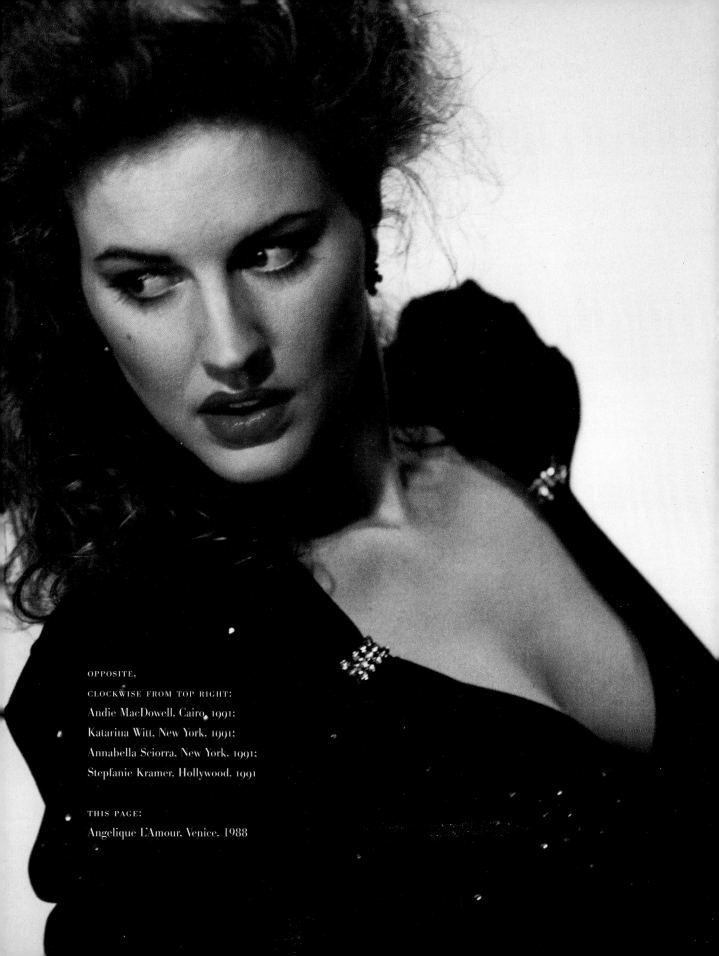

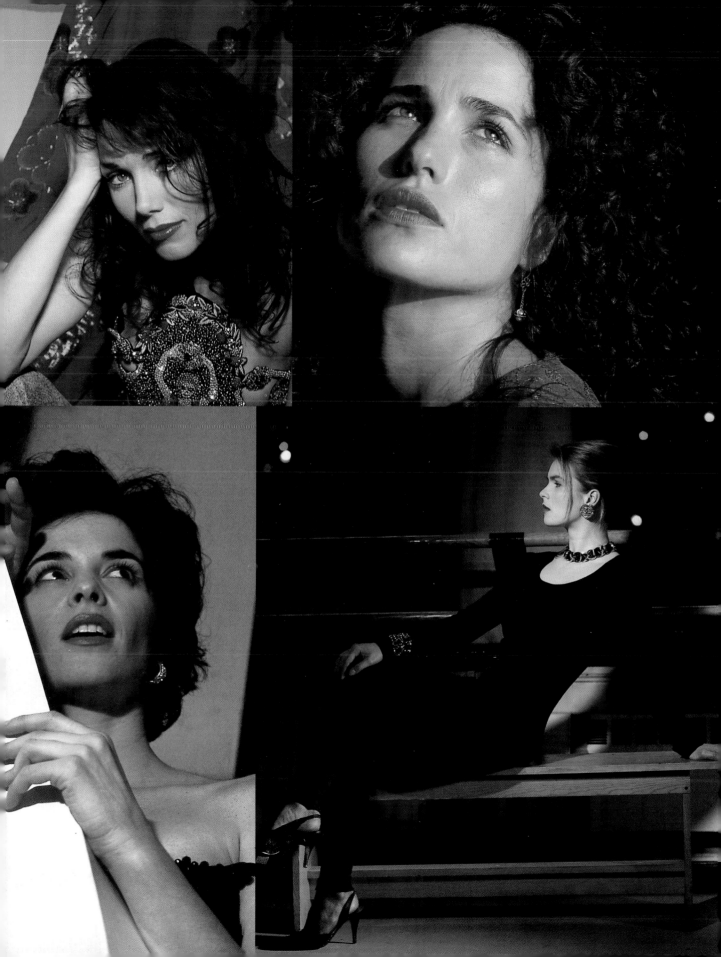

Jennifer Flavin | MALIBU, 1989

Friendly, nice, sort of your average gorgeous-girl-next-door, Jennifer Flavin was just beginning her career as a model when she came to Malibu to be photographed. Somewhat inexperienced, but eager to please, she handled the long difficult day of location and wardrobe changes with good humor. Her new boyfriend, Sylvester Stallone, was offering her a great deal of support and encouragement, and she wanted him to be proud of her. In 1990, she played the delivery girl in *Rocky V*, and in 1997 she became Jennifer Stallone.

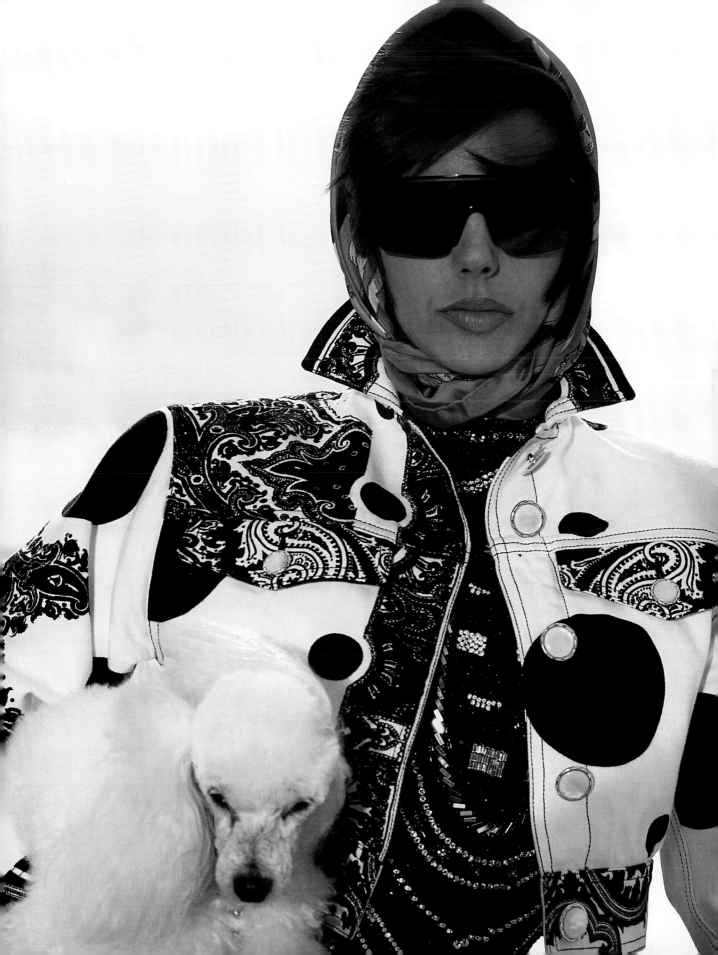

Arielle Dombasle | LA CÔTE D'AZUR, C. 1974

Each year, in May, Cannes becomes *the* place to be; oglers, cigar chompers, autograph hunters, stalkers, pickpockets, exiled royalty, paparazzi, celebrity photographers, and media mavens arrive in high style to participate in the annual starlet convocation—the Cannes Film Festival. It's not *that* warm during the festival, but that would never stop the array of comely, ubiquitous starlets from posing in their skimpiest bikinis—least of all the winsome Arielle who quite fancied her star-designed USA-inspired version.

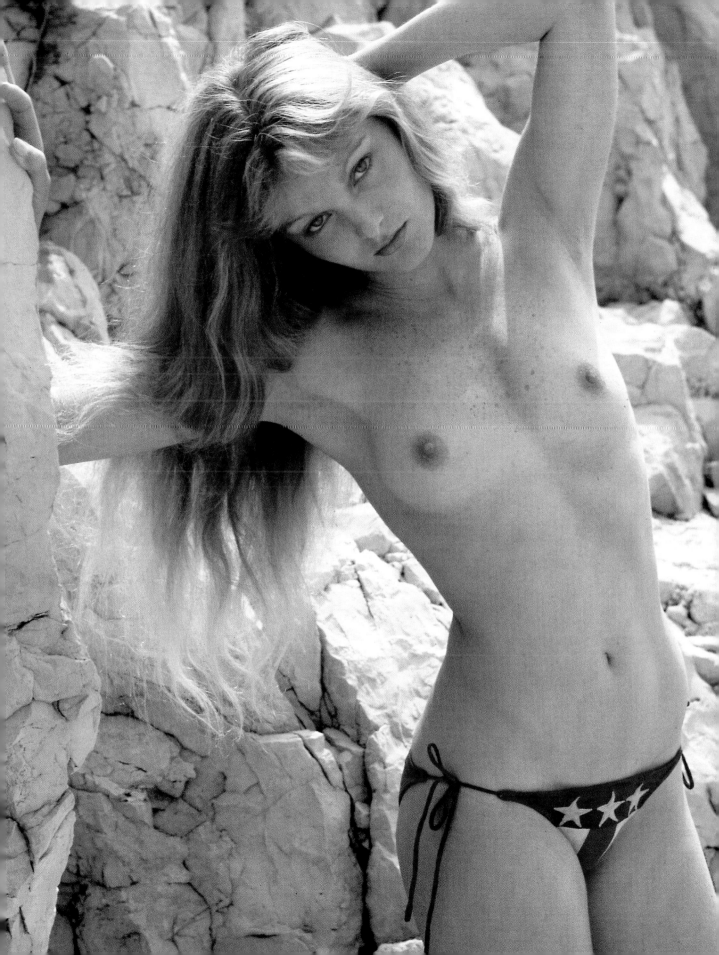

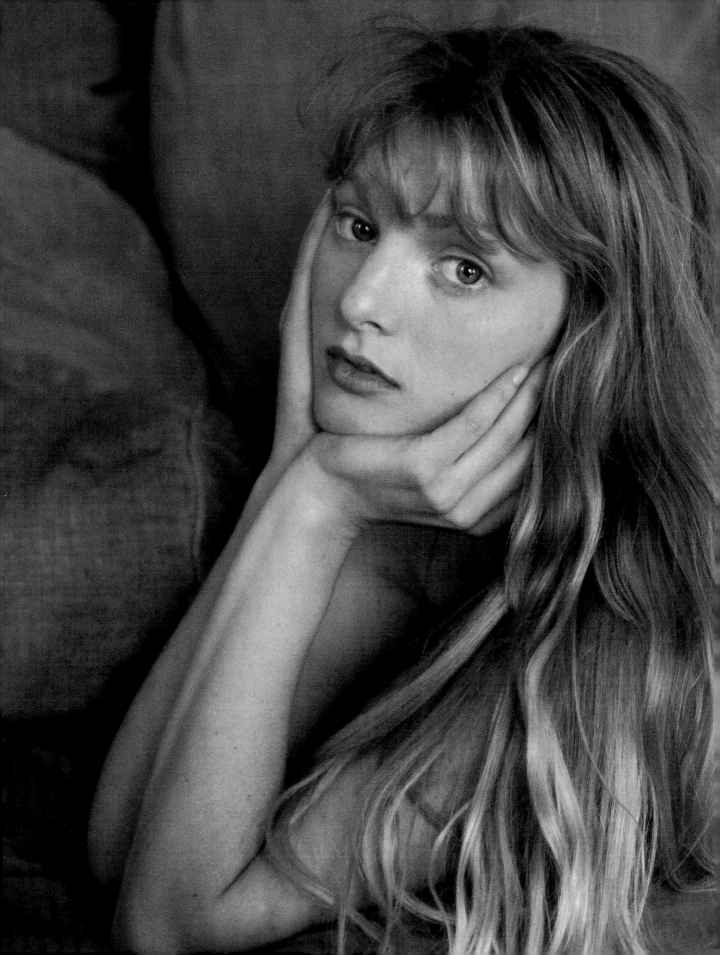

ARIELLE DOMBASLE | PARIS, C. 1973

Born Sonnery De Fromental in Norwich, Connecticut, this blithe yet headstrong spirit chose Paris—not Hollywood—to seek stardom.

Our session was at her apartment near the Arc de Triomphe. Afterward we all dined together at La Route Mandarin on Rue des Beaux Arts. During dinner Arielle casually opened her purse and pulled out a *lit* sparkler. Magic was definitely her mischief.

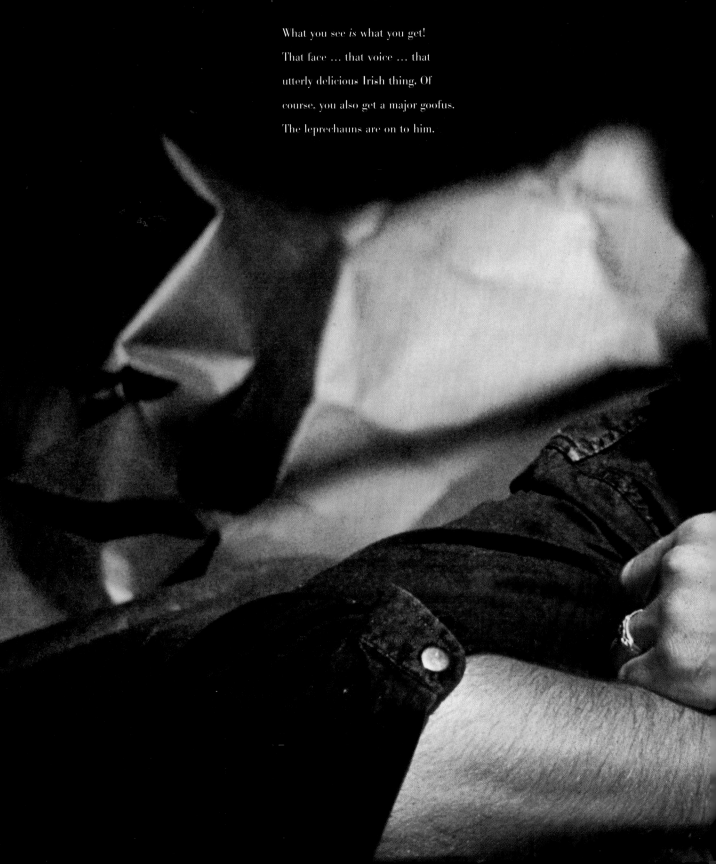

Pierce Brosnan | VENICE, 1985

What you see *is* what you get!
That face ... that voice ... that
utterly delicious Irish thing. Of
course, you also get a major goofus.
The leprechauns are on to him.

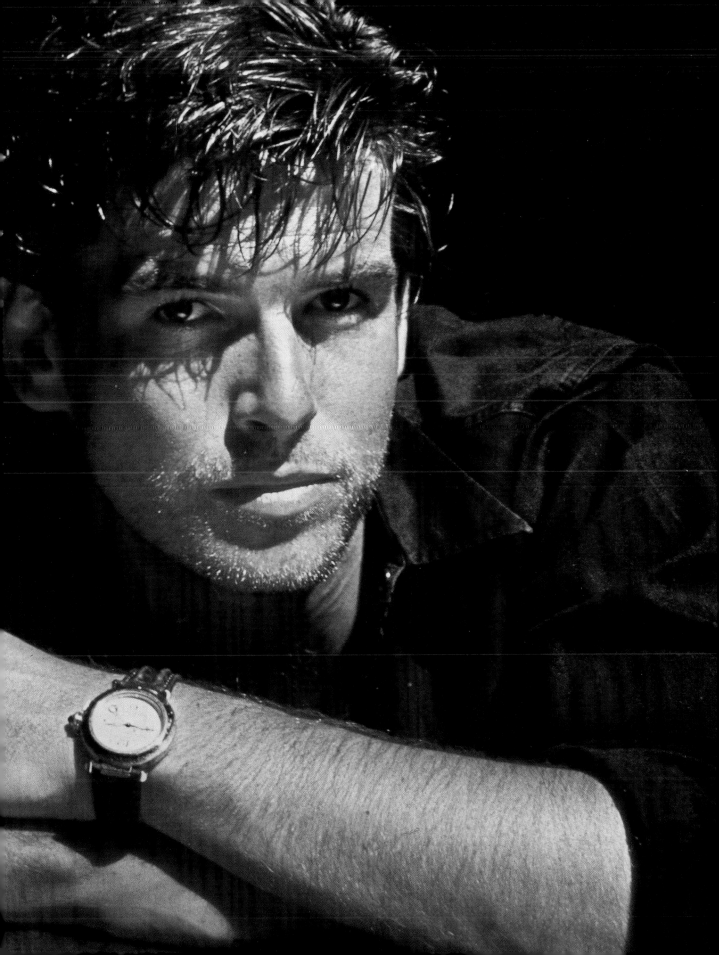

Christopher Lambert | Venice, 1985

How could someone from Great Neck, Long Island, be so French? Christophe Guy Denis Lambert—at age two—moved to Geneva, and later to Paris and the Conservatoire. He returned home and to his first American film *Greystoke: The Legend of Tarzan, Lord of the Apes.* He arrived at my studio one evening exhausted from a long hard day. I decided to shoot his fatigue. The results were "tres fatigue, tres Belmondo." I loved the session and Christopher did too, since he didn't have to *do* anything—that is, if you call looking beaten-up-sexy not doing anything.

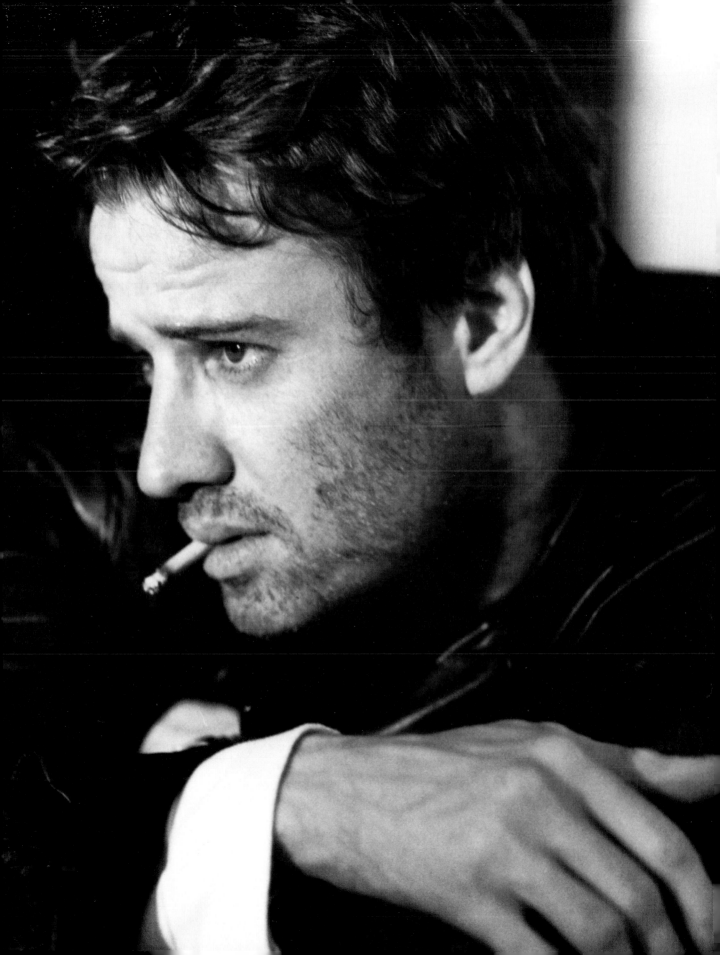

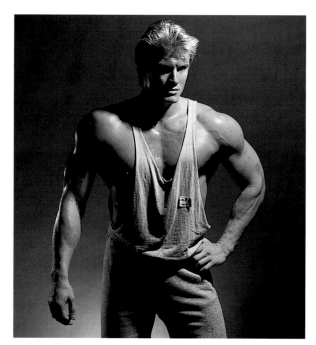

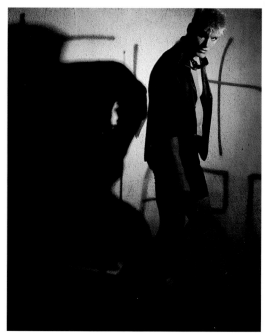

Dolph Lundgren | VENICE, 1985

Drago, the Soviet Fighting Machine in *Rocky IV*, aka Dolph Lundgren, was in my Venice studio dressed in his red boxing shorts and little else—unless you count 6´6˝ of brawn as attire! (Why didn't I have nude models in my drawing classes that looked like him?)

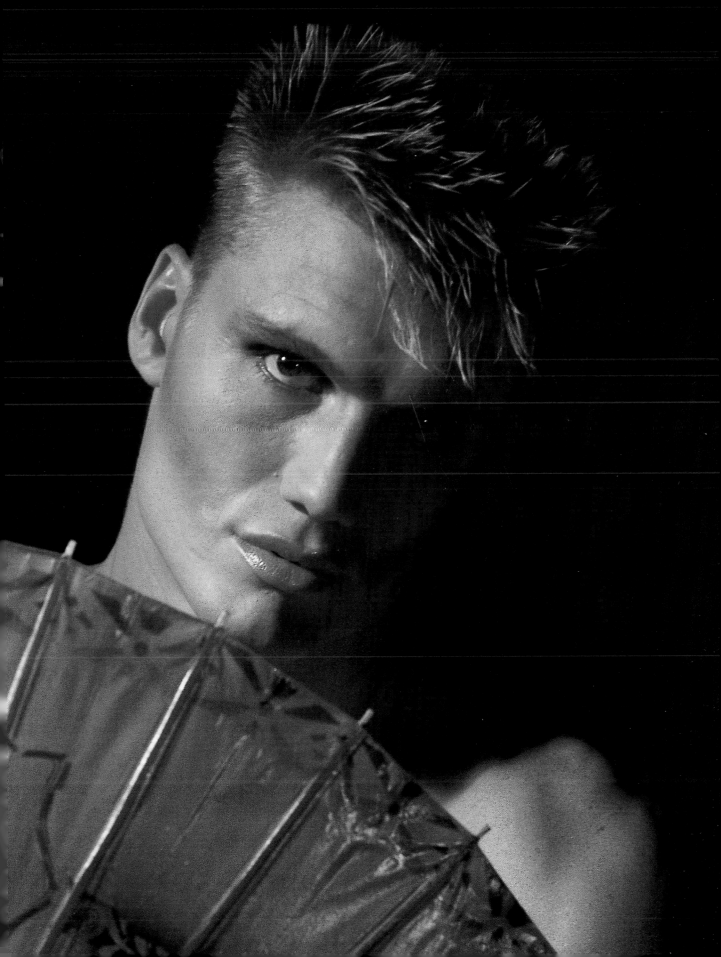

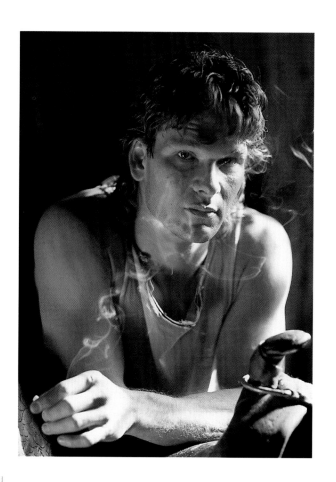

Patrick Swayze | RANCHO BIZARRO, 1987

Like the rest of the world I discov-
ered Patrick Swayze as the pulsating
virile, blue-collar heartthrob in *Dirty
Dancing.* So naturally, at some point
during our photo session at his ranch
in the San Fernando Valley, I just

could not help but suggest that he'd
look really cool galloping across a
field naked and bareback.

I don't know which rattled him
more—riding bareback or bareassed.

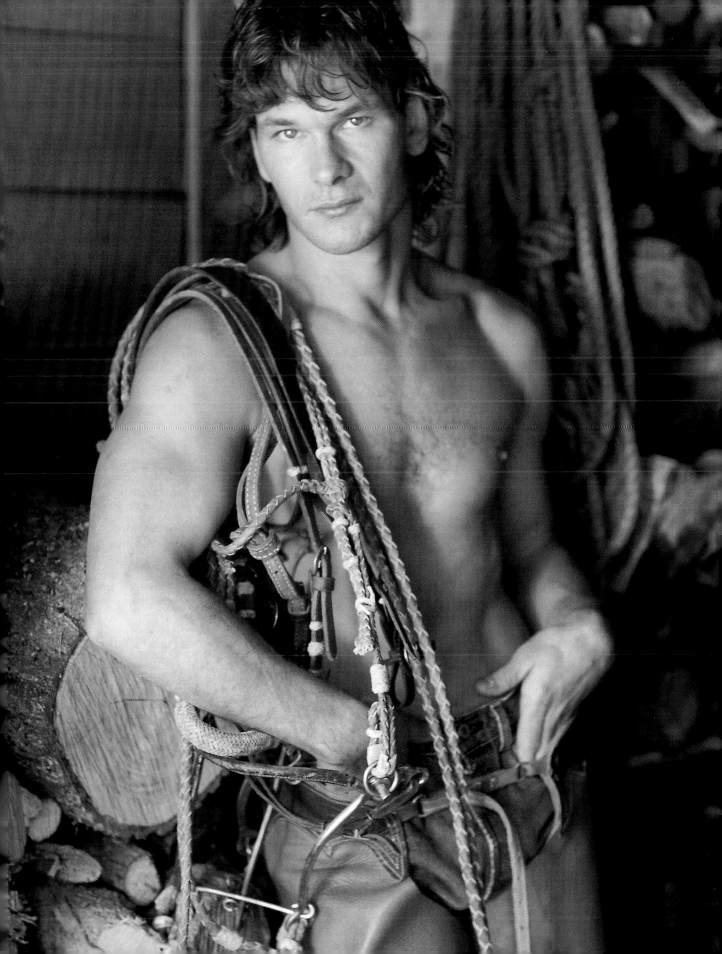

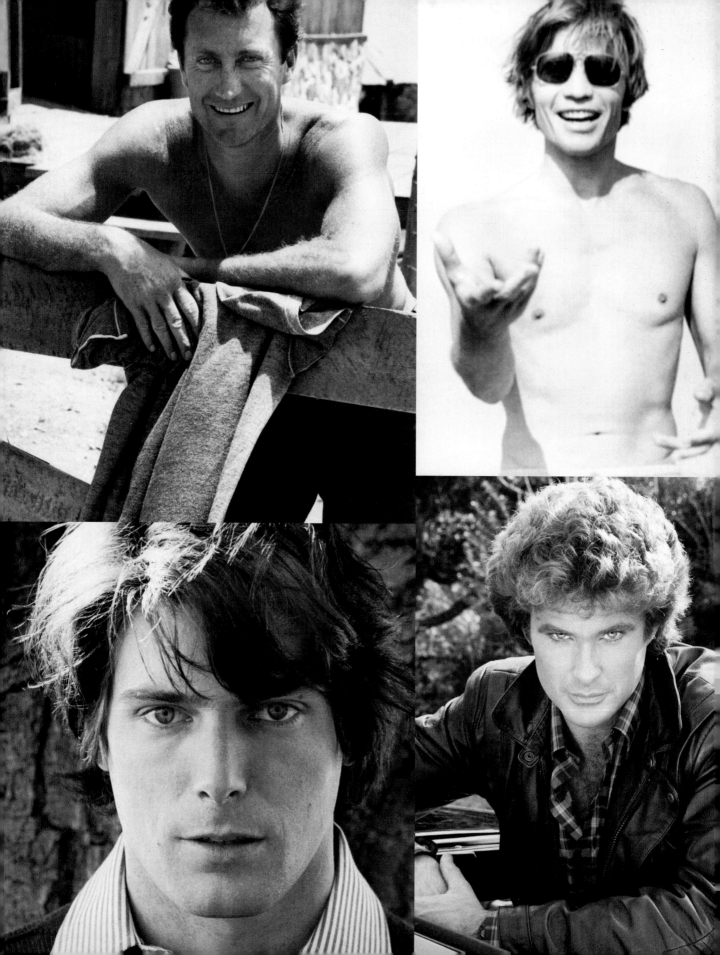

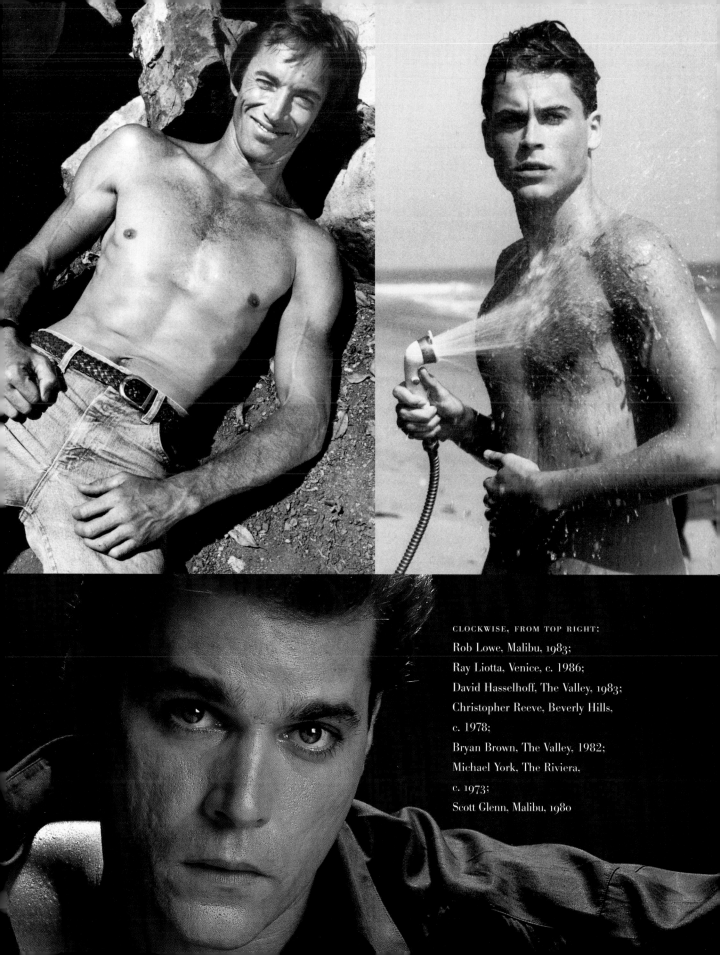

CLOCKWISE, FROM TOP RIGHT:
Rob Lowe, Malibu, 1983;
Ray Liotta, Venice, c. 1986;
David Hasselhoff, The Valley, 1983;
Christopher Reeve, Beverly Hills,
c. 1978;
Bryan Brown, The Valley, 1982;
Michael York, The Riviera,
c. 1973;
Scott Glenn, Malibu, 1980

River Phoenix | Venice, 1986

He was fourteen when we first met. "I've been thinking about changing my name from River Phoenix to Rio—like Sting." "Or like Charo," I mused ironically. He must have dropped the idea.

We worked together frequently and each session produced a new reincarnation: River the coy toy boy, River the environmentalist, River the musician, River the maniac, River the dark prince ... but they all carried the same untamed covert energy. He was always expressive but camouflaged—always available but capable of bolting. His favorite shot was the darkest.

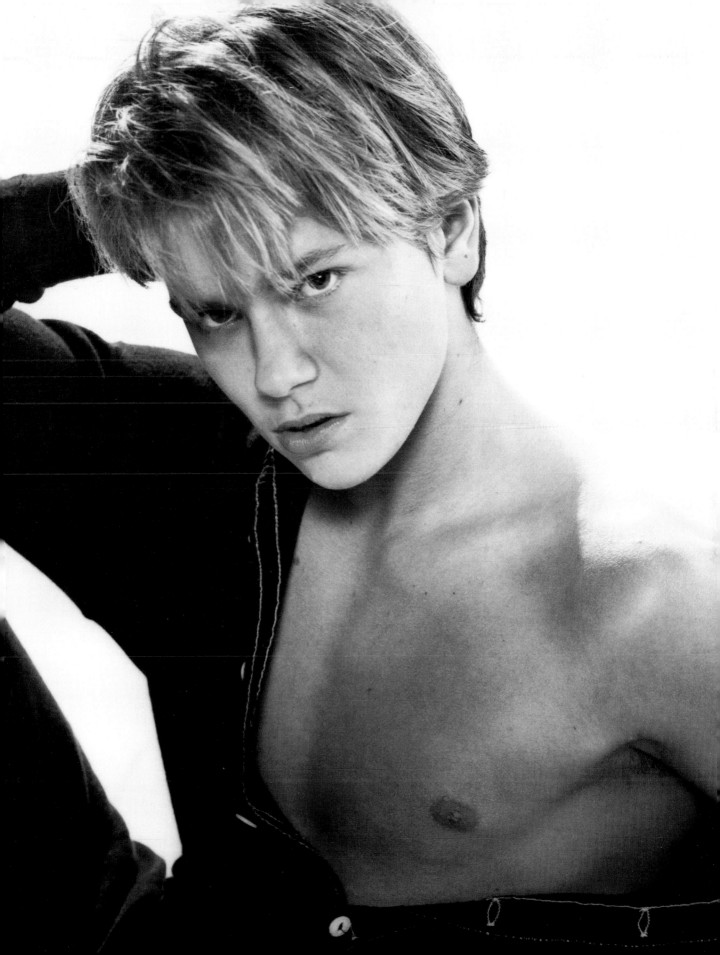

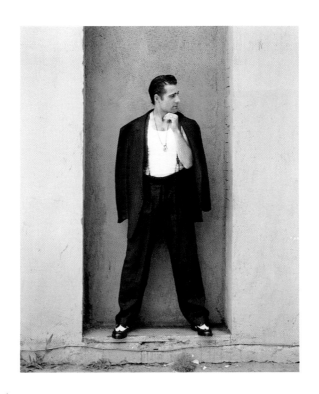

Adrian Pasdar |

A feature story on Adrian Pasdar for a far-out magazine, and I could do what I wanted. Yes!

In the Versace wardrobe that was provided for the shoot, Adrian reminded me of a post–World War II neo-realist Italian film star. So I took off his shirt, threw his jacket over his shoulders, and took to the streets where he could make lewd gestures for the camera (as in "nice ass!"). By the end of the shoot, Adrian had taken us to the edge of the envelope, where, checking his eye shadow, he gleefully jumped overboard. He was hauntingly handsome one moment and a gooney bird the next.

Adrian's married to one of the Dixie Chicks, Natalie Maines, and plans to have ten children! (Hey Adrian, have you discussed your plans with Mrs. Pasdar?)

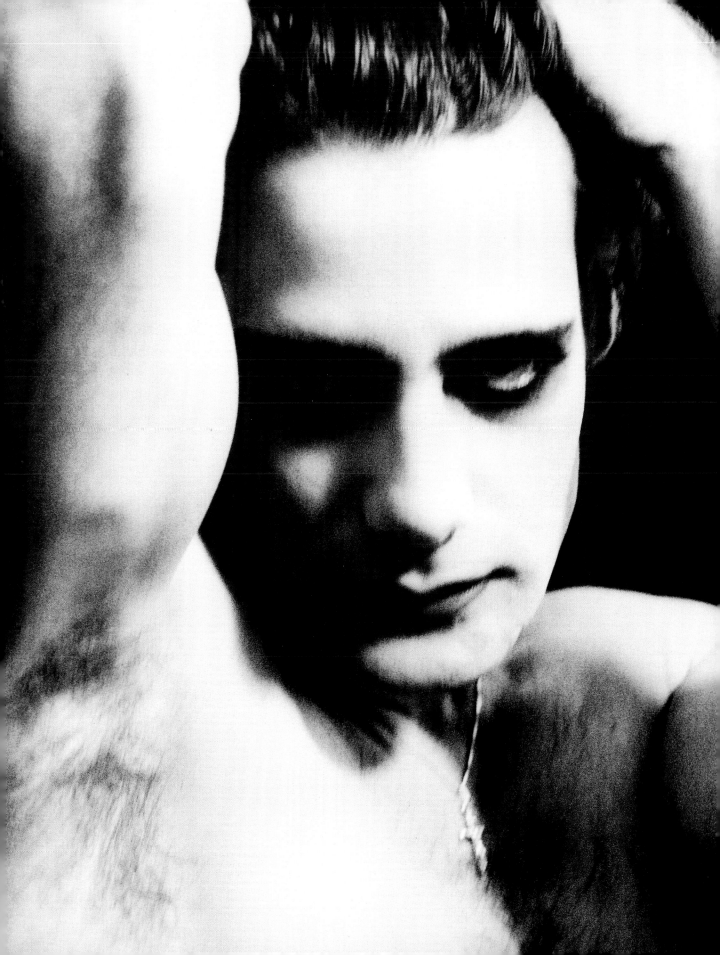

Nicholas Cage | MALIBU, 1985

Nicholas was just twenty-one when we had our first photo shoot, but I knew of him from *Birdy*. With his father August (a Comparative Lit professor), his uncle Francis (a film director), and his grandfather Carmine (a composer), Nicholas (born Nicholas Kim Coppola) had a cultural education genetically built into him. Our session—no surprise—had a wild improvisational energy to it: there was the brooding atonal music of an avant-garde Polish composer to set the mood (usually rock is requested), skulls for props, and ripped seamless paper as background. That day, with the mind of a mad genius and the eyes of a lost basset hound, he was Hamlet in a Hawaiian shirt. Come to think of it—all our sessions wandered off the road. Elvis and Sailor Ripley Live!

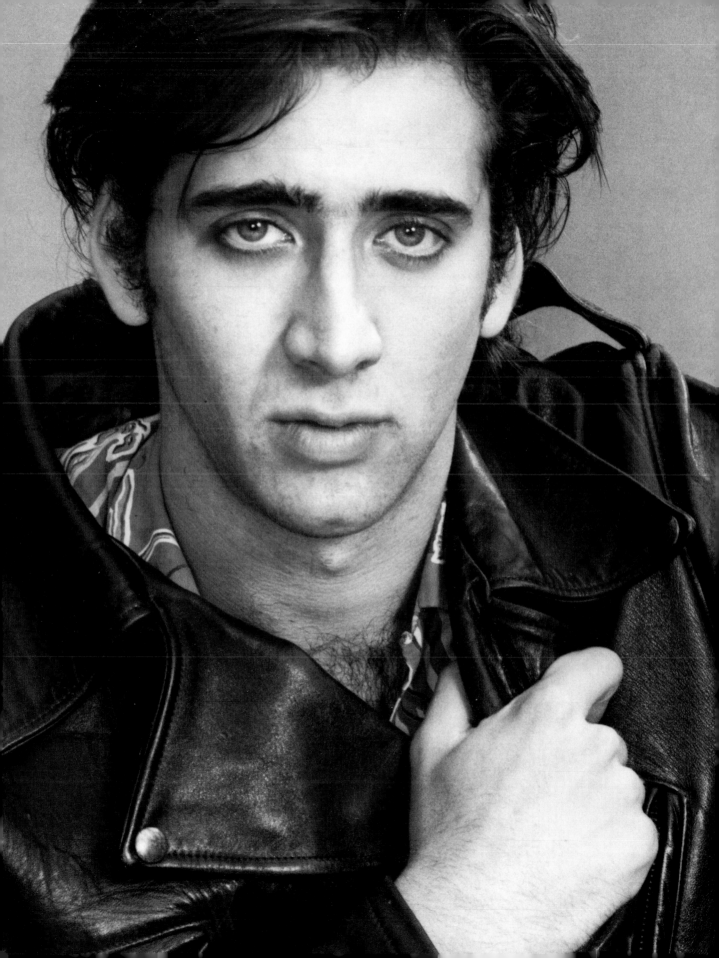

ACKNOWLEDGMENTS

To my art director, Anthony McCall,
and the McCall Associates design team;
to my editor Ellen Cohen and my publisher
Charles Miers at Universe/Rizzoli Publishing;
and to my assistant, Angela Titolo;
thank you, dearly.

. . . and to Paul Theroux, thank you for your
delicious intellect and literary libido.

First published in the
United States of America in 2001 by
UNIVERSE PUBLISHING
A Division of Rizzoli International
Publications, Inc.
300 Park Avenue South
New York, NY 10010

2001 2002 2003 2004 / 10 9 8 7 6 5 4 3 2 1

Printed in Italy

Art direction and book design:
Anthony McCall Associates, New York